IMAGES
of America

LAKE CITY

IMAGES
of America

LAKE CITY

Duane Vandenbusche and Grant Houston

ARCADIA
PUBLISHING

Copyright © 2019 by Duane Vandenbusche and Grant Houston
ISBN 978-1-4671-0274-2

Published by Arcadia Publishing
Charleston, South Carolina

Printed in the United States of America

Library of Congress Control Number: 2018958881

For all general information, please contact Arcadia Publishing:
Telephone 843-853-2070
Fax 843-853-0044
E-mail sales@arcadiapublishing.com
For customer service and orders:
Toll-Free 1-888-313-2665

Visit us on the Internet at www.arcadiapublishing.com

*This book is dedicated to my Belgian farming community
of St. Nicholas in the Upper Peninsula of Michigan.*
—Duane Vandenbusche

*This book is dedicated to my longtime friends Tom and Mary Curry,
with many happy memories of our high-country adventures in years past.*
—Grant Houston

CONTENTS

ACKNOWLEDGMENTS

Thanks go to many individuals, libraries, and museums for the use of their photographs in this book. The Hinsdale County Museum (HCM), Colorado Historical Society (CHS), Denver Public Library (DPL), New York Public Library (NYPL) and US Geological Survey (USGS) were of great help in providing photographs and information. Special thanks go to the *Lake City Silver World* newspaper (LCSW) for providing numerous photographs for the book.

Individual photography credits include Henry Benson (HB), Margaret Cummings Brown (MCB), Vivian Ramsey Brown (VRB), Edmund Burke (EB), Jean Conover (JC), Ann Ewart Davidson (AED), Martin Davis (MD), Bill Eloe (BE), William Ewart (WE), Russell Gammon (RG), Andy Gunning (AG), Anning Hammond (AH), Florence Baker Heald (FBH), Herman Heath (HH), Edna Beam Hoffman (EBH), Althea Knowlton (AK), Butch Knowlton (BK), Milo Morse (MM), Carol Carey Perry (CCP), Roger Kadz (RK), Eileen Rawson (ER), Jean Blair Ryan (JBR), Rikki Santarelli (RS), Jane McLeod Smith (JMS), Bob Stigall (BS), Duane Vandenbusche (DV), Ruth Vernon (RV), Shirley Lewis Vickers (SLV), Betty Wallace (BW), John White (JW), and Clarence Wright (CW).

We are very grateful for the support, wisdom, and expertise of our title manager Stacia Bannerman and Arcadia Publishing. Special thanks to Pam William of historic Island Acres Resort in Gunnison, Colorado, who scanned all the photographs in this book. Lastly, we thank the people of Lake City past and present for their inspiration, friendship, and support.

INTRODUCTION

Lake City, 8,671 feet high on Colorado's Western Slope, is located in the high and beautiful San Juan Mountains and was once called "the metropolis of the San Juan." Surrounded by 14,000-foot-high mountains and protected by Slumgullion Pass over 11,000 feet and Cinnamon, Engineer, and Stony Passes approaching 13,000 feet, Lake City was an isolated paradise and the place to be when gold and silver were found in the 1870s.

Two streams—the Lake Fork of the Gunnison River and Henson Creek—merge at Lake City. While building a toll road through this region in 1874, road builders Otto Mears and Enos Hotchkiss found gold. Lake City, named for nearby Lake San Cristobal, sprang up as if by magic following the discovery. By the late 1870s and early 1880s, an estimated 4,000 people had come to the new mining camp. Rich mines like the Ute-Ulay, Ocean Wave, and Golden Fleece announced the arrival of a great new mining camp.

The miners around Lake City braved isolation, numbing below-zero temperatures, heavy snow, and Ute Indians in their quest for gold and silver. Optimism ran high during the halcyon early years. Smelters were built, the Denver & Rio Grande (D&RG) Railroad laid a grade into the camp in 1881, brick buildings dotted the camp, and the rich mines brought in many well-known and excited investors. Lake City was soon named the county seat of Hinsdale County.

Suddenly, in the early 1880s, the mining boom ended almost as quickly as it had begun. The mines did not have the high-grade gold and silver ore found in the other great San Juan mining camps of Ouray, Silverton, Telluride, and Animas Forks. By 1890, despite the entry of the Denver & Rio Grande the year before, the good times were all gone. Lake City's mining revived periodically after 1890, but the population of Hinsdale County plummeted to the second lowest in Colorado.

Today, Lake City has a year-round population of 400 and has become a tourist mecca. Thousands come in the summer to enjoy the cool days, perpetual sunshine, nearby Lake San Cristobal, jeep tours in the mountains, and great fly fishing on the many streams. Lake City in 2018 is an outdoor paradise with a glorious past.

One

METROPOLIS OF THE SAN JUAN

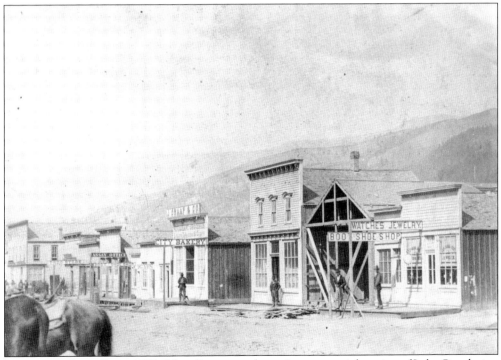

DOWNTOWN LAKE CITY, 1877. Silver Street was the main commercial section of Lake City during the height of the mining boom in the 1870s. A jewelry store, assay shops, saloons, and restaurants dominate the street. A fire in 1915 destroyed all these buildings. (JBR.)

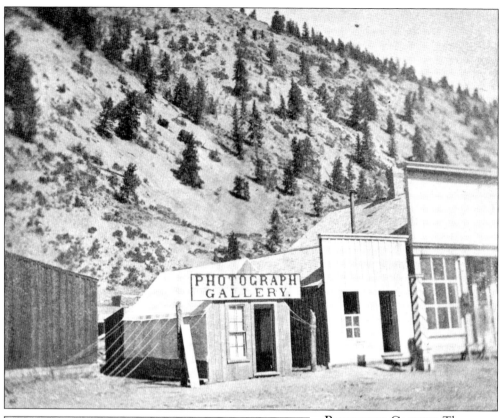

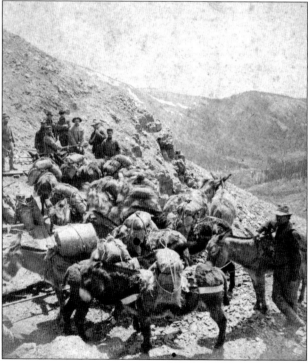

Barnhouse Gallery. Thomas Barnhouse was from Western Virginia and a Civil War veteran. He was an undertaker and sheriff before arriving in 1876 in Lake City. There, he opened his photograph gallery on Silver Street and became the earliest photographer in Lake City history. (LCSW.)

Headin' for the Hills. A pack train near Leadville laden with supplies heads for the San Juan country in the late 1870s. Before railroads, pack trains followed narrow and treacherous trails into the mining country. (LCSW.)

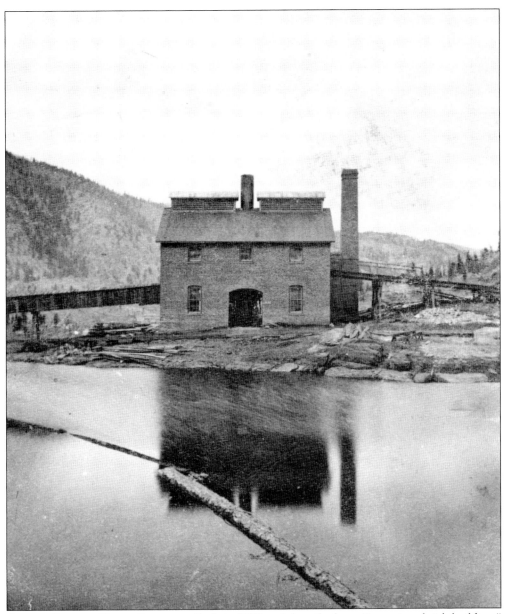

CROOKE SMELTER BLAST FURNACE. Built in 1878 and described as a "capacious brick building," the blast furnace was a key feature of the Crooke Smelter and was equipped with a water jacket furnace, which produced 200-pound silver and lead ingots. The brick building was also used as a refuge for a possible Ute Indian attack. (LCSW.)

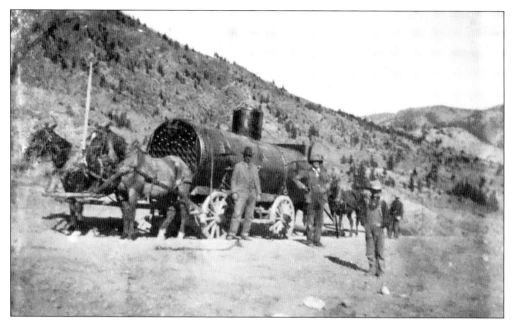

WATSON BROTHERS FREIGHTING, 1880s. Sam and James Watson were two ex-Confederates from Virginia. Desiring a new start, the two came to Lake City in 1876 and started the leading freighting company of the region. Here, on the south side of Lake City, the brothers are taking a huge steam boiler up the Lake Fork of the Gunnison River to a mine. (BK.)

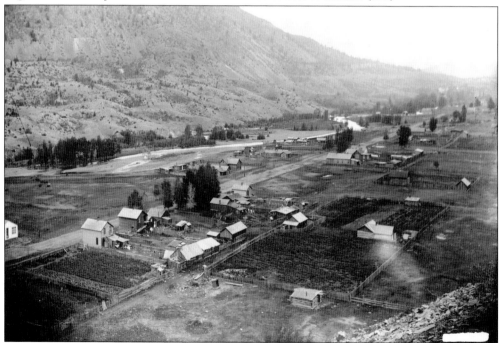

WADE'S ADDITION. Named for founder Samuel Wade, this addition came into being in 1877 between Lake City and the Crooke Smelter. The Lake Fork of the Gunnison River meanders through the addition. Wade later left Lake City and founded Paonia in the nearby North Fork Valley. (LCSW.)

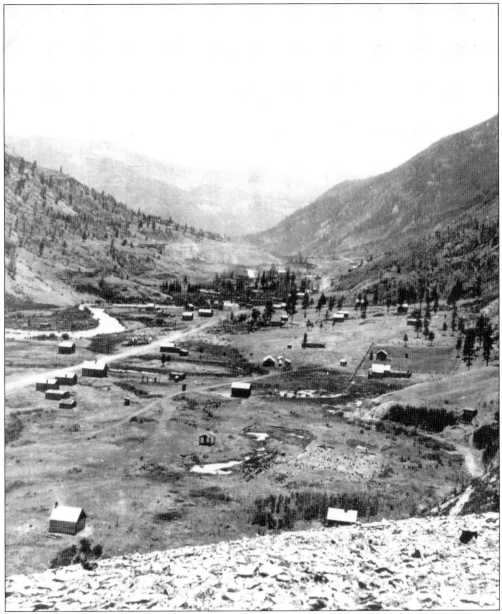

CROOKEVILLE. By 1880, Crookeville, which came into being because of the Crooke Smelter south of Lake City, had 75 houses and a population of 200 and was looked upon as another promising mining camp of the San Juan country. (LCSW.)

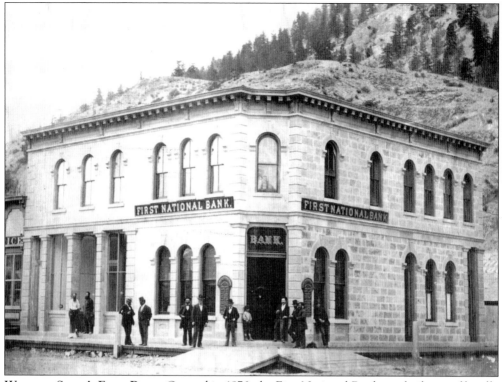

WESTERN SLOPE'S FIRST BANK. Opened in 1876, the First National Bank was built out of locally quarried sandstone for $22,000. Lounging in the doorway in 1877 is H.A. McIntire, bank president. McIntire caused the bank's collapse in 1878 when he was convicted of embezzlement of $40,000 in bank funds. (LCSW.)

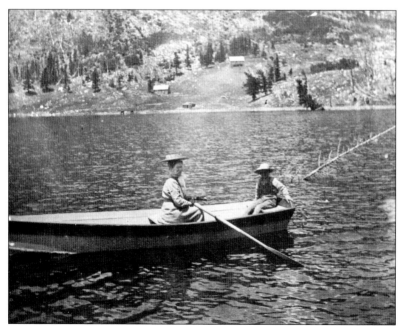

SUNDAY ON THE LAKE. A Lake City woman and her son are on an outing on beautiful Lake San Cristobal before 1900. The lake was a favored recreational area for residents of Lake City, who used it for picnics and fishing. (DV.)

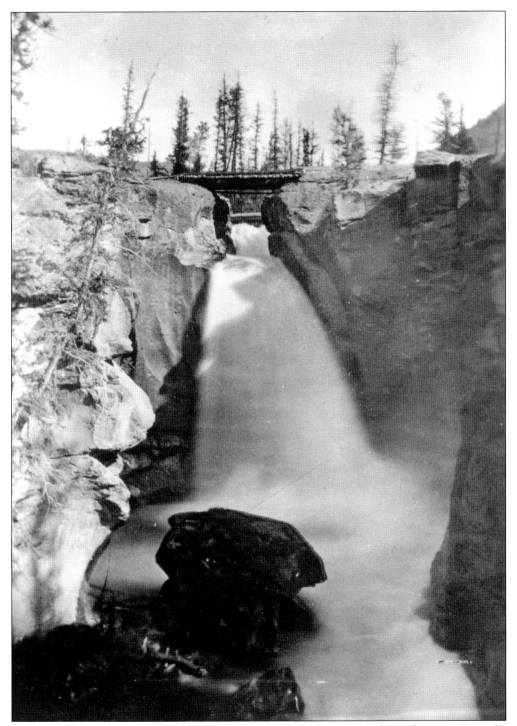

GRANITE FALLS. Located on the Lake Fork of the Gunnison River about three-quarters of a mile from Lake City, Granite Falls drops 50 feet. The falls provided the power for Lake City's first sawmill in 1875. The following year, John J. Crooke built a smelter there, and the name was changed to Crooke Falls. (USGS.)

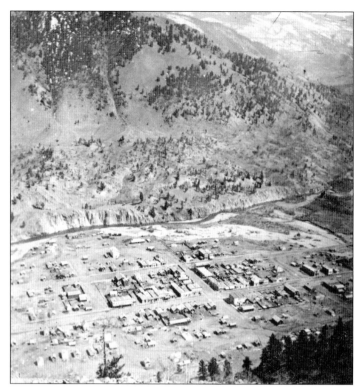

LAKE CITY, 1877. Taken from Neoga Mountain, this Thomas Barnhouse photograph shows Lake City at the peak of the building boom in 1877. The Lake Fork of the Gunnison River winds its way along the east side of Lake City. (LCSW.)

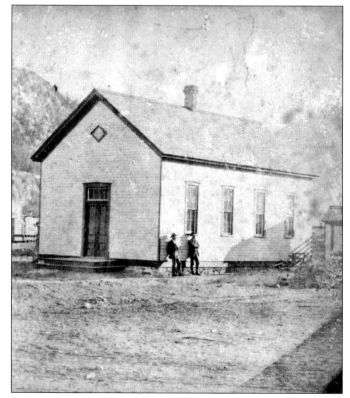

WESTERN SLOPE'S FIRST CHURCH, 1876. Built by Presbyterian minister George Darley and brother Alexander in 1876, this church still stands and continues in use today as the oldest church on Colorado's Western Slope. Father Darley wrote about his ministerial travels outside of Lake City in the San Juan country in *Pioneering in the San Juan*. (NYPL.)

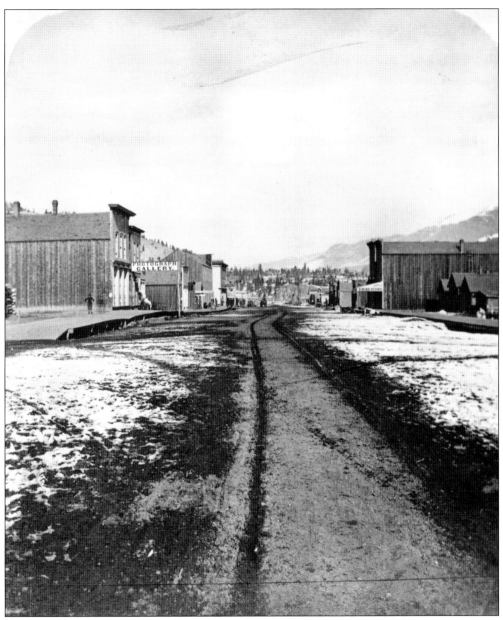

GUNNISON AVENUE, LAKE CITY. One of the major streets of Lake City in 1880, Gunnison Avenue was very wide to handle the many wagon trains coming into the mining camp. On the left is a high boardwalk, and on the right is the two-story Avenue Dining Hall. (LCSW.)

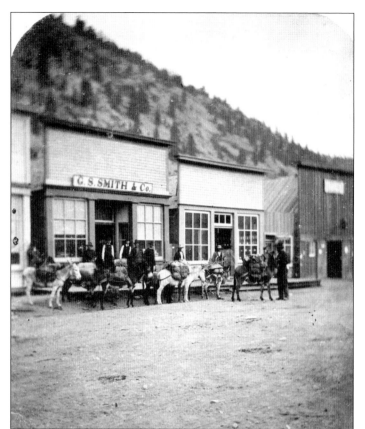

G.S. Smith Express. A pack train laden with supplies prepares to leave the G.S. Smith mercantile store on Silver Street in 1880. Smith owned the Palmetto mine just below Engineer Pass, where the supplies are headed. (LCSW.)

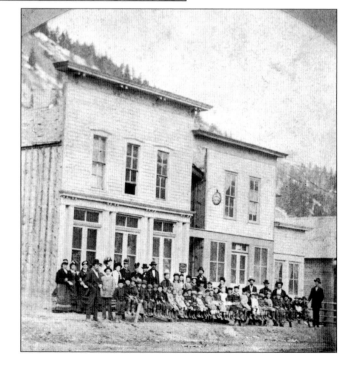

Sunday School. Students in Lake City escorted by parents line up for a photograph on Gunnison Avenue in 1876. The building on the left was one of the earliest schools in Lake City. On the right is Thomas Barnhouse's photograph gallery. (LCSW.)

Lixivation Works. The Van Gieson Lixivation Works was built in 1876 for $35,000 near downtown Lake City. It processed sulfur ore from nearby mines. W.H. Van Gieson was the inventor of the brass cartridge shell. The works had a short life of three years. (DPL.)

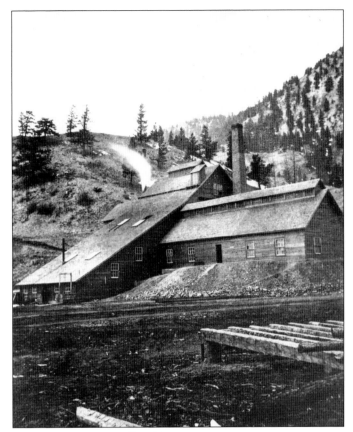

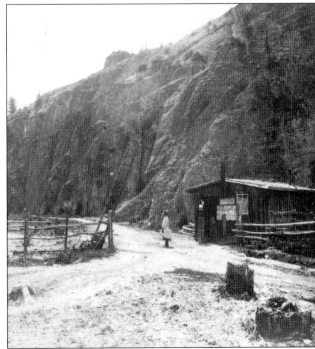

Lake City–Uncompahgre Toll Gate, 1876. This private toll road ran from Lake City to Capitol City, then to Engineer Pass at nearly 13,000 feet. From there, it dropped into Ouray along the Uncompahgre River. The road had 16 bridges in the first two miles along Henson Creek and ran for 35 miles. Shown here is the toll gate just outside of Lake City. (LCSW.)

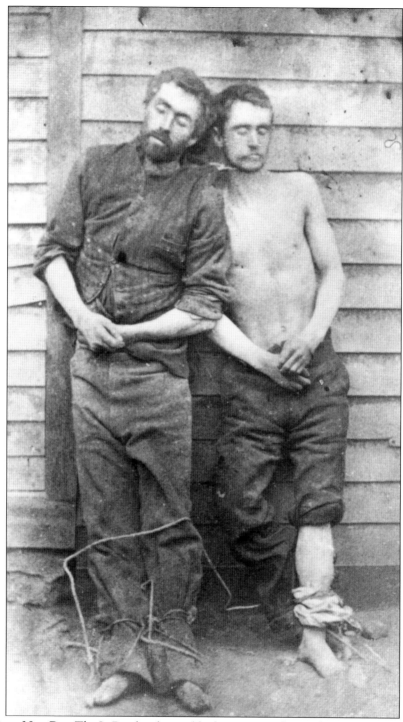

CRIME DOES NOT PAY. The LeRoy brothers robbed stages in Pitkin, Lake City, and Del Norte in 1880 and 1881. They were captured by Del Norte sheriff Lew Armstrong and put in jail. A mob broke into the jail and hung the two men from a cottonwood tree in Del Norte, after which the men's bodies were photographed. (JC.)

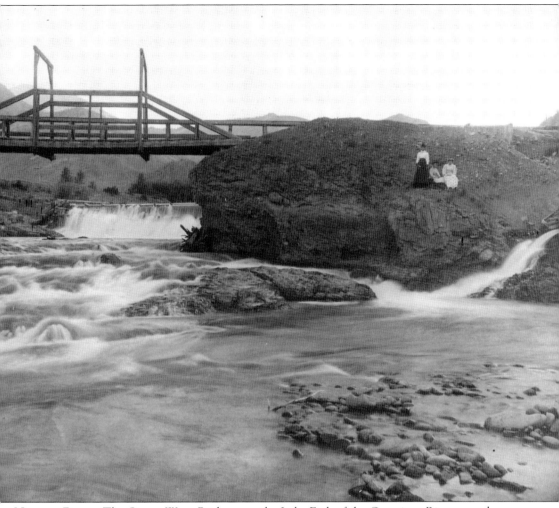

NECKTIE PARTY. The Ocean Wave Bridge over the Lake Fork of the Gunnison River was where saloon keepers George Betts and James Browning were hung in 1882. The two men killed Lake City sheriff Edward Campbell in the process of a robbery. They were hung from the bridge by an angry mob comprised of 75 masked men. (RK.)

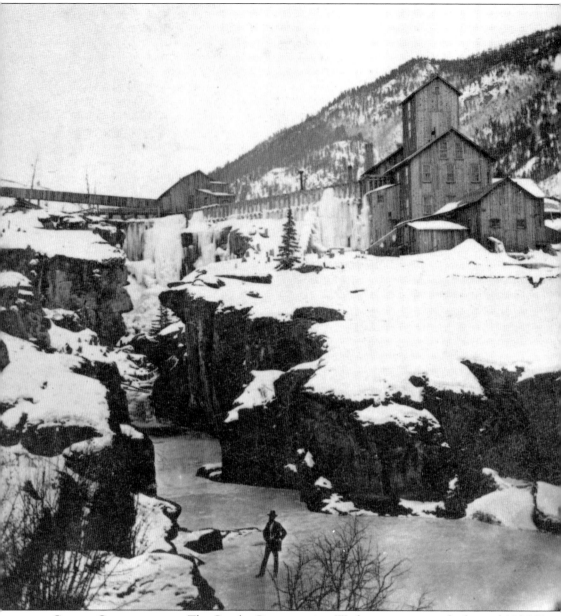

CROOKE CONCENTRATOR. The Crooke Concentrating Works was six stories high, used 100,000 board feet of lumber, and was dedicated on July 4, 1876. The concentrator was located at Crooke Falls on the Lake Fork of the Gunnison River. In 1876, it was one of the largest concentrators in the United States. (LCSW.)

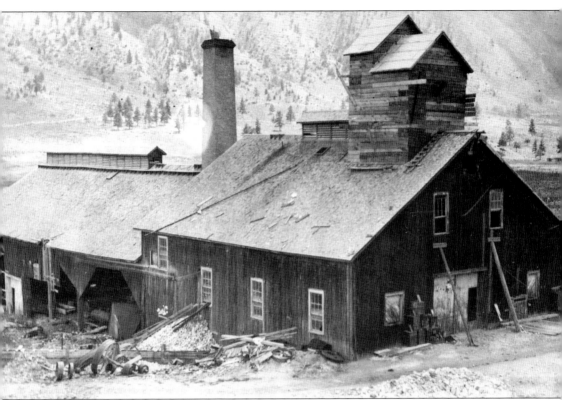

OCEAN WAVE SMELTER. One of Lake City's several smelters, the Ocean Wave on the north end of town was built in 1877 for $42,000. The smelter, which was powered by water, had a capacity of 100 tons a day. This photograph was taken in 1911, thirty-one years after the smelter was built. (AH.)

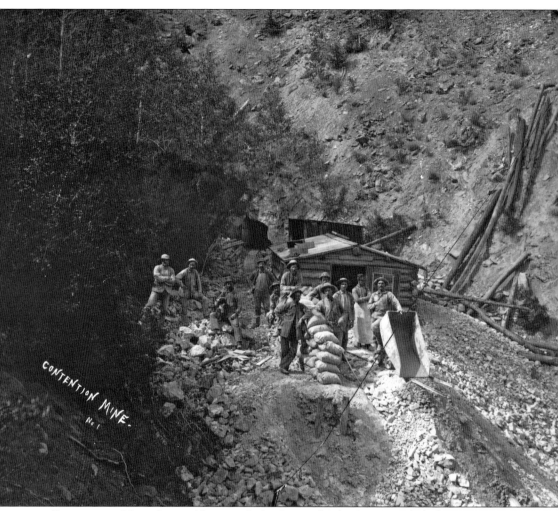

CONTENTION MINE. Located between Lake City and Lake San Cristobal, the Contention Mine was one of the earliest in San Juan County, dating to the 1870s. Here, a group of miners has sacked some ore ready for shipment. (DV.)

Two

THE EARLY YEARS

UTE CHIEF. In 1874, William H. Jackson photographed the Ute Indian Agency at Los Pinos. He recalled, "This was an immense collection of Indian lodges with their attendant herds of horses and crowds of women and children." Jackson was in luck to be able to photograph this chief. Later in the day, the Indians refused to be photographed. (LCSW.)

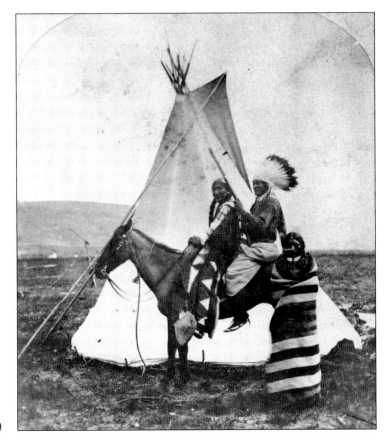

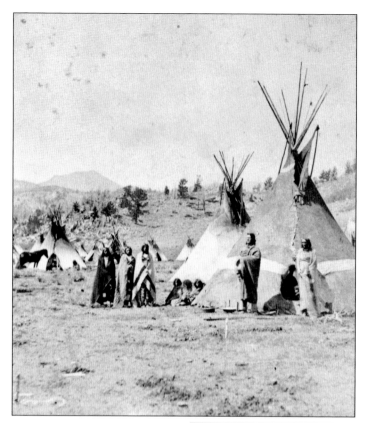

WAR CHIEF LODGES. In 1874, the Ferdinand Hayden expedition was allowed to photograph the Los Pinos Ute Indians. William H. Jackson, the greatest photographer in the history of the West, took this picture of the war chief lodges. (LCSW.)

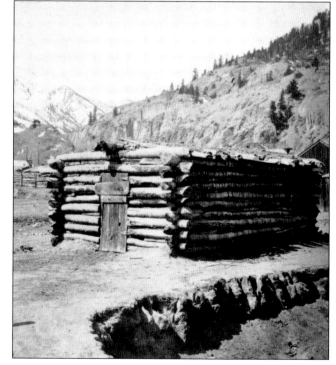

FIRST CABIN. While building the Saguache–San Juan Toll Road, Enos Hotchkiss built the first cabin in Lake City in August 1874. The cabin was demolished five years later because of the mining boom. (LCSW.)

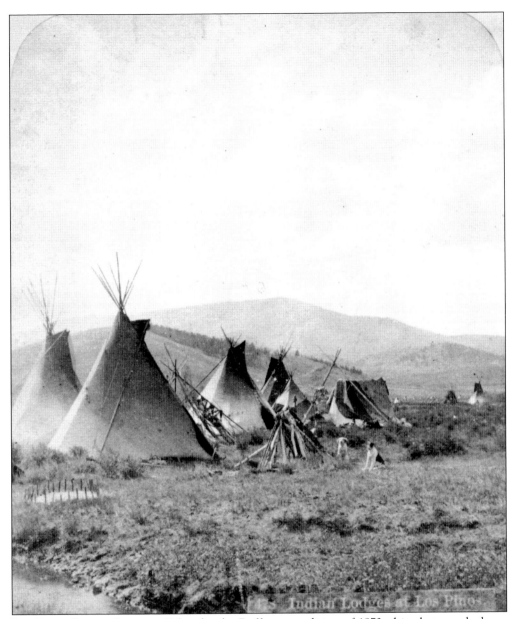

LOS PINOS INDIAN LODGES. Taken by the Ruffner expedition of 1873, this photograph shows the Indian Lodges at the Los Pinos Agency not far from Lake City. The Utes would not allow themselves to be photographed—"No bueno, make Indians heap sick." (LCSW.)

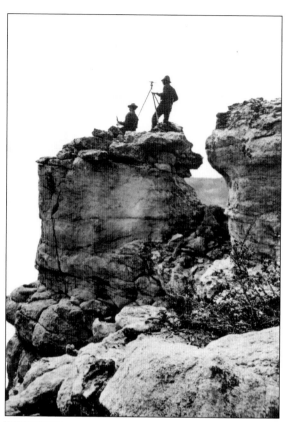

HAYDEN'S MEN. Ferdinand Hayden was one of the four great surveyors of the American West. The surveyors operated in the West from 1867 to 1879. Here, G.B. Chittenden and W.H. Holmes engage in triangulation on a peak en route to the Lake City region. (USGS.)

SAGUACHE. Founded in 1866, Saguache (a Ute Indian word meaning "Blue Earth") was the jumping off point to Lake City. Here, wagon trains and miners headed into the rich mineral country via the Saguache–San Juan Toll Road, built in 1874. (CHS.)

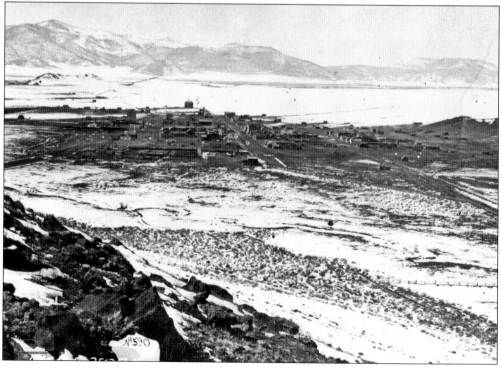

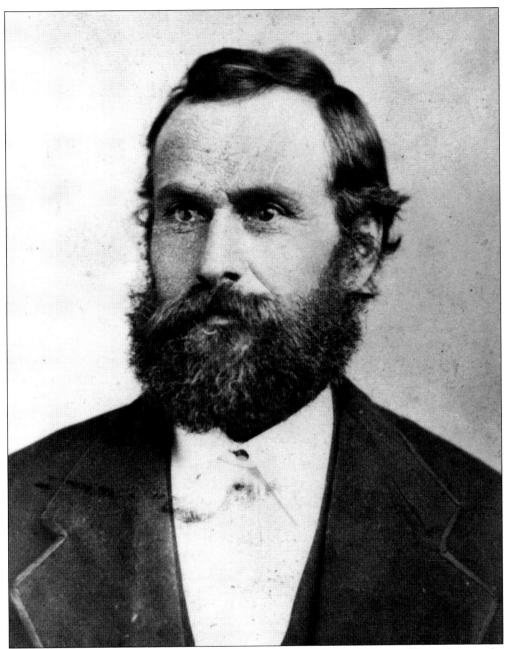

LAKE CITY FOUNDER. While building a primitive road from the supply camp of Saguache into the San Juan mining camps in 1874, Enos Hotchkiss and his men hit gold. This discovery led to the start of Lake City, a soon-to-be booming mining camp. Hotchkiss finished the road and later became one of the top ranchers in western Colorado, with a town named for him today. (LCSW.)

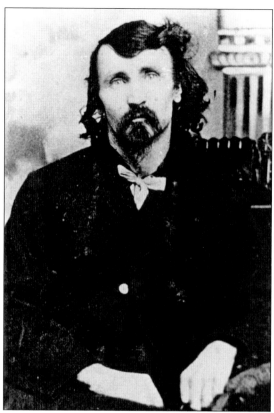

THE COLORADO CANNIBAL. Alferd Packer and five other miners became lost during the early winter of 1874 heading for a mining strike near Breckenridge on Colorado's Western Slope. Packer was the only one to arrive, appearing at the Los Pinos Indian Reservation in April. He was later convicted of five counts of manslaughter and sentenced to prison. Packer stayed alive in the mountains by eating parts of the five victims. (CHS.)

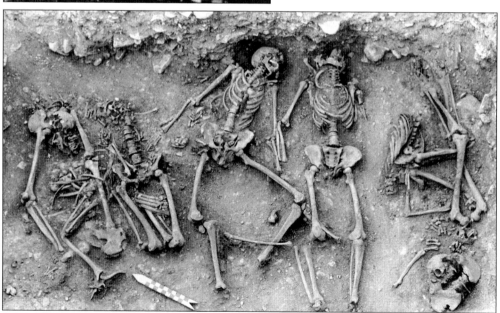

PACKER VICTIMS. The remains of Alferd Packer's victims were exhumed in July 1989 just outside of Lake City. The bones were of Shannon Bell, George Noon, Israel Swan, Frank Miller, and George Humphrey. Prof. James Starrs, who exhumed the bodies, concluded all victims had been killed by blunt and sharp force, with scrapes to the bone indicating removal of flesh. (LCSW.)

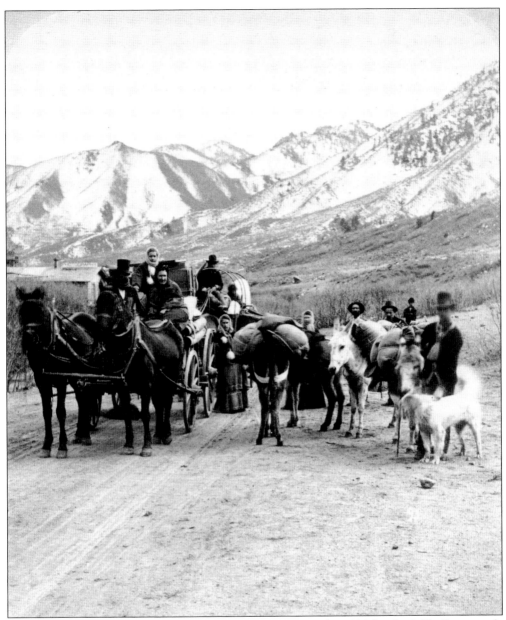

"SAN JUAN OR BUST." A small wagon train makes it way over the 9,114-foot-high Ute Pass outside Colorado Springs, heading for booming Lake City in 1876. The train still has over 125 miles to go before getting into the widely heralded camp. (LCSW.)

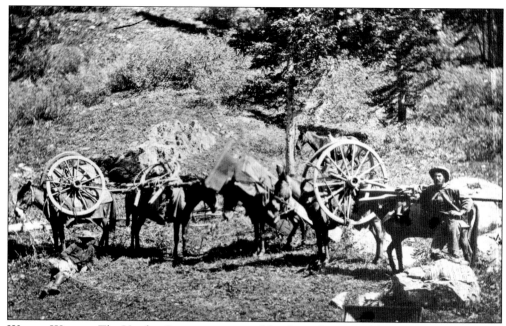

WAGON WHEELS. The Hayden Survey, one part of the Great Surveys of the American West from 1867 to 1879, often had to take its wagons apart to get them over the high passes and rough country of Colorado. Here, Hayden's men rest near Lake City in 1875 before ascending a pass. (USGS.)

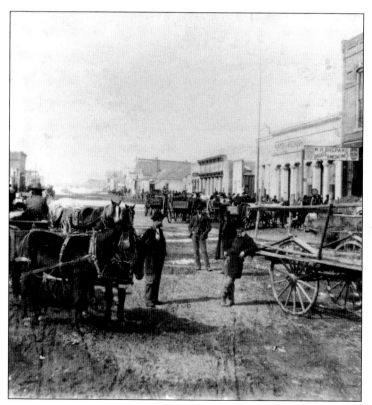

DEL NORTE. Started in 1871, Del Norte, on the Rio Grande River, soon became a major supply town for Lake City. Supplies were brought in from near the head of the Rio Grande over Slumgullion Pass via the Antelope Park and Lake City Toll Road. (LCSW.)

MERCHANDISE FIRM, 1876. The firm of Boot and Company originated in Mineral Point near the headwaters of the Uncompahgre River. Shortly after it began, the merchandise company expanded and opened a branch at Rose's Cabin on the east side of Engineer Pass. Here, burros at Rose's Cabin are packed up and ready to head into San Juan mining camps. (HCM.)

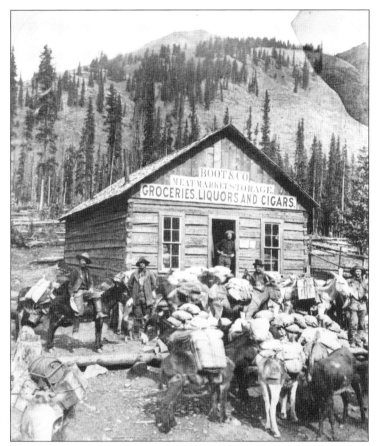

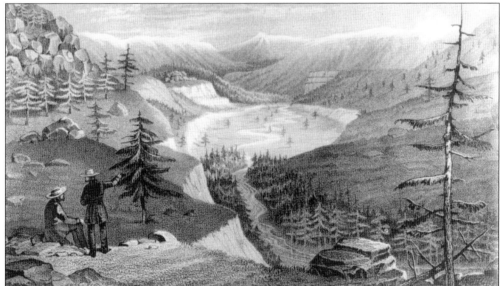

MILLER FLATS AND "THE GATE." This 1850s-era artist's rendering is the earliest known picture of the famous "Gate" and Miller Flats, 16 miles north of Lake City. The Lake Fork of the Gunnison River winds its way through the Gate and Flats. (CHS.)

HEADING UP THE PASS. A heavily laden burro pack train heads up Ute Pass out of Colorado Springs in 1875, headed for Lake City, deep in the San Juan Mountains. The trusty burro was the only means of getting supplies in and ore out of mining camps in the early days before roads were built. (LCSW.)

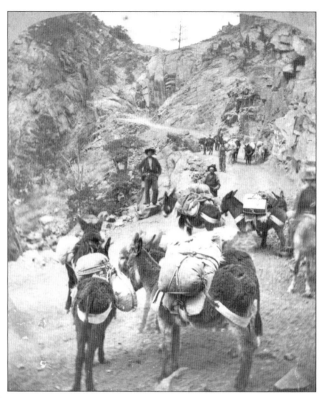

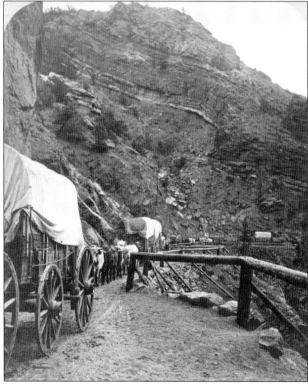

WAGON TRAIN. A long wagon train laden with supplies for Lake City winds its way up Ute Pass in the late 1870s. Supply towns for Lake City and the other San Juan mining camps were far away, and prices were very high in the isolated camps. (LCSW.)

Three

HENSON CREEK

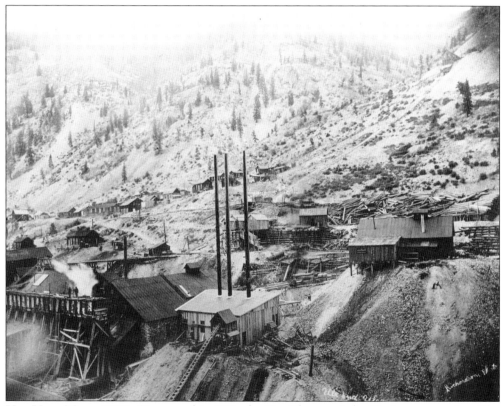

UTE-ULAY MINE, 1900. Discovered in 1871, the Ute-Ulay was Lake City's greatest mine. The mine was named for the Ute Indians on whose land the miners were trespassing, as well as for Chief Ouray ("Ulay"). About 250 men worked at the mine, which eventually produced in excess of $14 million. (CW.)

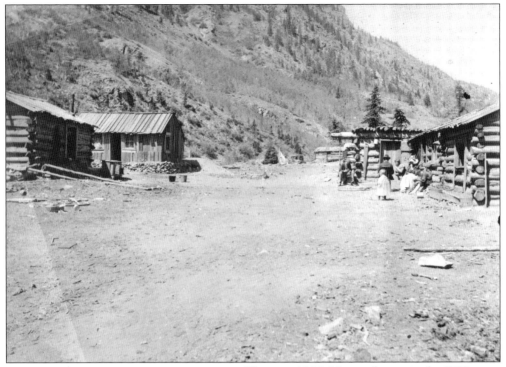

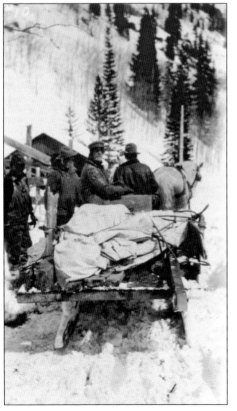

HENSON, 1899. Henson began in the 1880s as a home for Italian miners who worked at the nearby Ute-Ulay mine. The little settlement had a post office, store, several saloons, and a school. The school was used for community meetings and musical operas. (HH.)

HAULING THE BODIES. A massive avalanche off Gravel Mountain during the winter of 1929 smashed into the Empire Chief Mine boardinghouse, killing four men. Here, the frozen men are being taken to Lake City. (LCSW.)

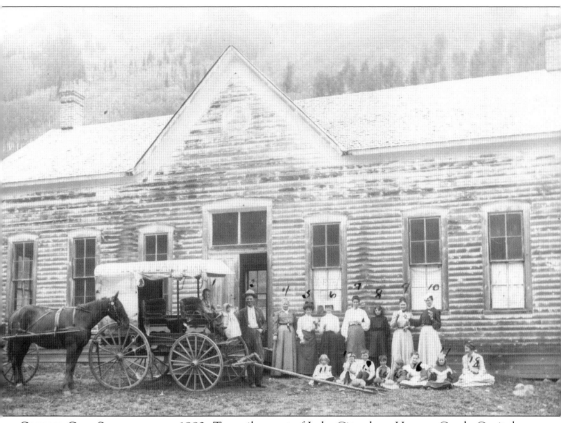

Capitol City Schoolhouse, 1883. Ten miles west of Lake City along Henson Creek, Capitol City grew up as a promising mining camp in 1876. The peak population was 300, and it served as a supply center for nearby mines. Here, the Capitol City Stage is in front of the school, with driver Ed Ewing pausing for a photograph with teacher and pupils at the turn of the 20th century. (HCM.)

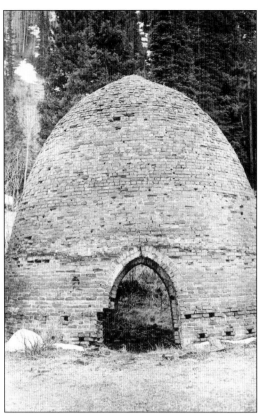

BEEHIVE COKE OVEN. Built in 1878 on the outskirts of Capitol City, this beautiful brick beehive coke oven stands today as the oldest surviving oven in Colorado. It provided coke as fuel for two nearby smelters along Henson Creek. (LCSW.)

STARTING FOR THE HOOSIER BOY. Family and friends pose before the Witherite Store and Capitol City post office in 1915 before embarking on a picnic at the Hoosier mine along Henson Creek. (FBH.)

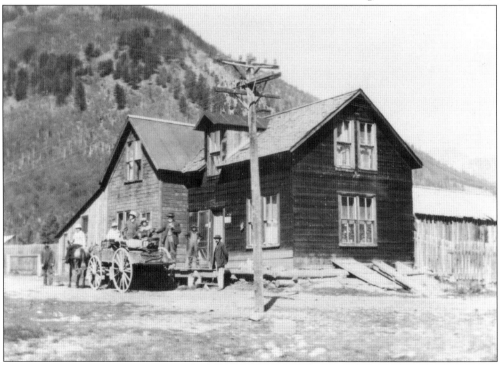

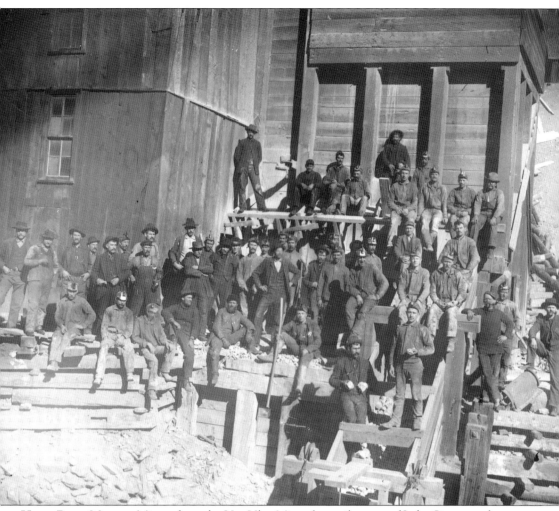

HARD ROCK MINERS. Miners from the Ute-Ulay Mine, four miles west of Lake City, pose for an 1895 photograph. The miners came from a score of nations, including England and Italy. The English were known as "Cousin Jacks" because when one was killed in the mine, one of his coworkers would try to get a relative hired, saying, "My cousin Jack can do that." (HCM.)

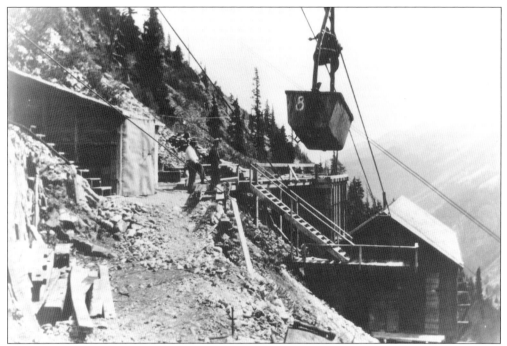

EMPIRE CHIEF TRAM, 1925. Midway between Capitol City and Rose's Cabin, the Empire Chief was one of the top lead producers of the Lake City region. The tram buckets carried 500 pounds of ore to the mill below. A deadly avalanche in 1929 destroyed many of the buildings and closed the mine. (LCSW.)

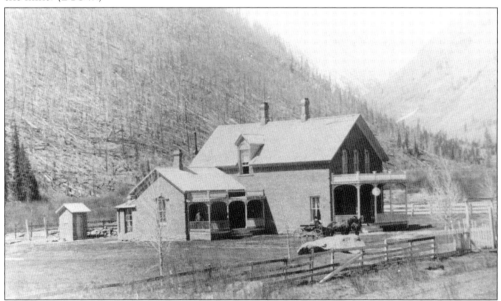

LEE MANSION, 1878. Built by George Lee in 1878 at Capitol City, this two-story brick mansion was one of the showplaces of the San Juan country. All bricks were manufactured in Capitol City. Mary Jane Lee raised exotic plants in the conservatory. George advertised his mansion as the Mountain House Hotel, which he occupied as his home from 1878 to 1882. The mansion fell into ruin after 1900, and nothing remains today. (LCSW.)

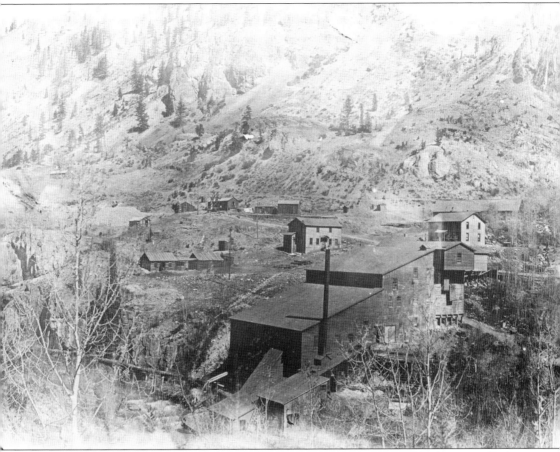

Hidden Treasure Mine. Discovered along Henson Creek, three and a half miles west of Lake City, the Hidden Treasure was one of Lake City's top mines. It had a gravity tram running from mine to mill and produced silver, lead, and zinc. In 1899, the Western Federation of Miners struck and took over, necessitating the calling of the Colorado National Guard. (CW.)

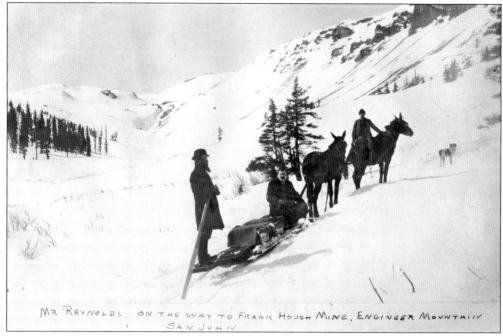

Handwritten caption on image: MR REYNOLDS ON THE WAY TO FRANK HOUGH MINE, ENGINEER MOUNTAIN SAN JUAN

FRANK HOUGH EXPRESS. A.E. Reynolds (left), the largest mine owner in Colorado and one of the first to use electricity in the mines, stands with his guide en route with supplies to his Frank Hough silver mine near the top of Engineer Pass in 1907. (LCSW.)

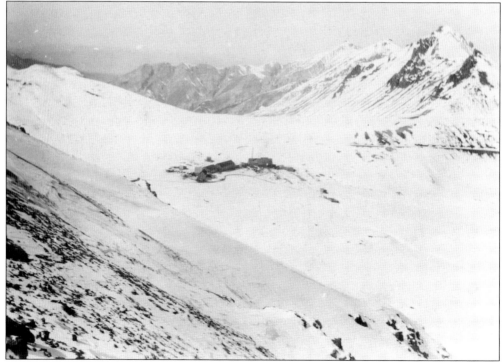

WINTERY MINING CAMP. The Frank Hough Mine boardinghouse and shaft house are 600 feet below Engineer Pass, at 12,200 feet, in this bitterly cold wintry scene in 1910. (FBH.)

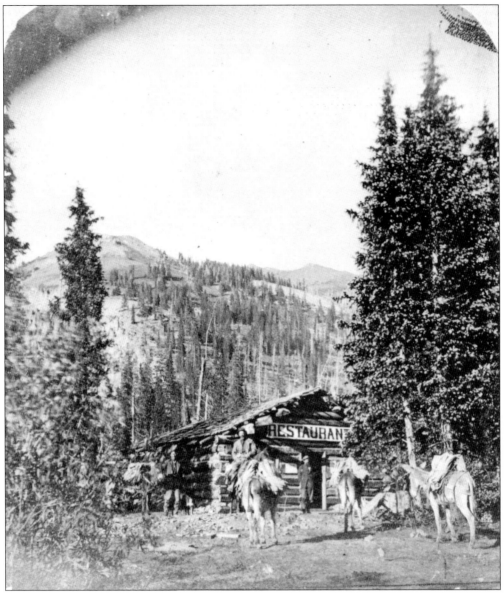

Rose's Cabin Restaurant. Four miles from the top of 12,856-foot-high Engineer Pass, Cordyon Rose established a boardinghouse and restaurant in the mid-1870s as a halfway house between Lake City on one side of the pass and Silverton and Ouray on the other side. (HCM.)

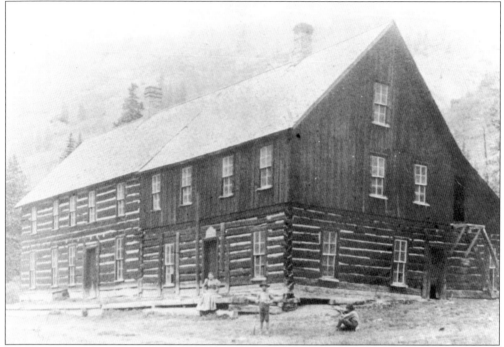

ROSE'S CABIN. Rose's Cabin began in the mid-1870s along Henson Creek and just below treacherous Engineer Pass. In the 1890s, when this photograph was taken, the cabin had been greatly enlarged by owners Charles and Augusta Schaffer. The two-and-a-half story log and frame building housed miners and travelers and had the longest bar in the San Juan. (LCSW.)

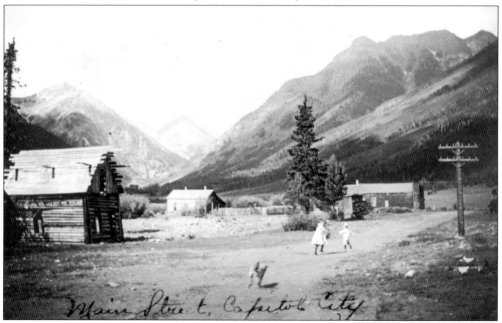

MAIN STREET, CAPITOL CITY. With Capitol Mountain in the right background, children and a dog play on Capitol City's main street. The mining was already in decline in 1909, although the settlement had once been one of the San Juan's most-promising mining camps. (FBH.)

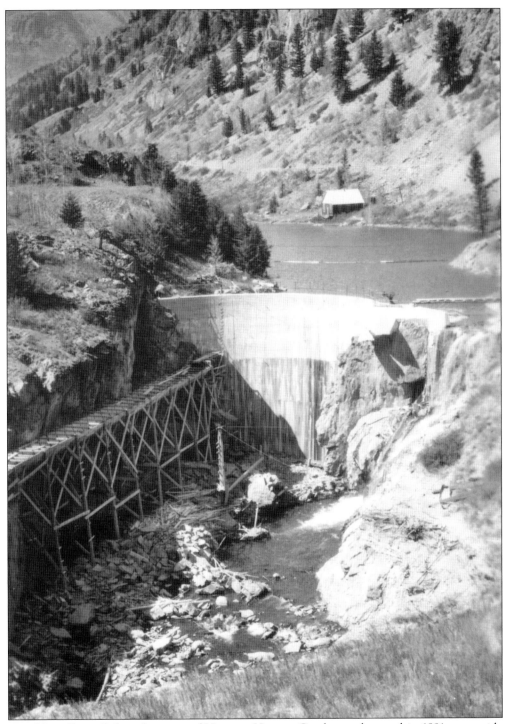

Ute-Ulay Dam. Below the town of Henson, Henson Creek was dammed in 1891 to provide water power via a 3,000-foot flume to the Ute-Ulay Mill. The cement dam is 50 feet high and was a wonder in the early days of mining. (FBH.)

PACK TRAIN, 1917. Two men are pictured next to their burros en route to a sheep camp in the high mountain meadows underneath Cinnamon and Engineer Passes. Burros were the unsung heroes of all mining camps in the San Juan Mountains. (FBH.)

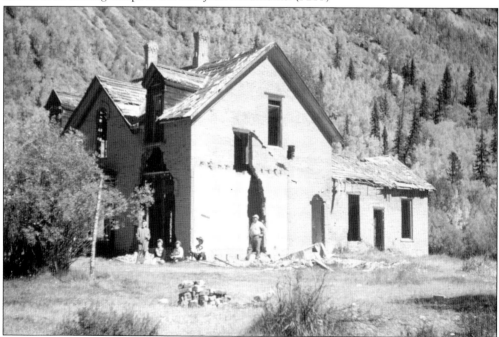

THE GOOD TIMES ARE ALL GONE. The Lee Mansion, once one of the great homes of the San Juan when built in 1878, was in ruin when this family visited in 1956. The bricks used to build it reportedly cost $1 each. The building, when constructed, included a library and a glass conservatory. (LCSW.)

Four

LAKE FORK OF THE GUNNISON RIVER

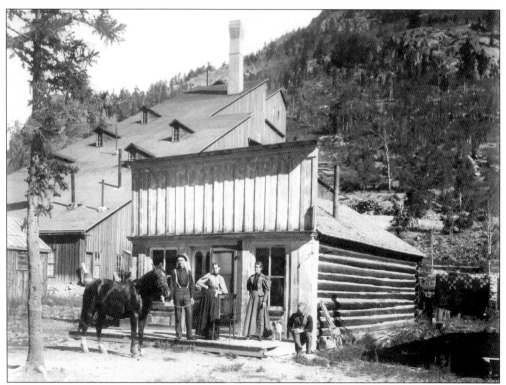

SHERMAN, 1896. Postmaster Homer Harrington (seated) with his wife, Maude, next to him, poses for a photograph next to the Black Wonder Mill and the Sherman Post Office. His dog Pugsie and horse Stanton wait patiently in front. (RK.)

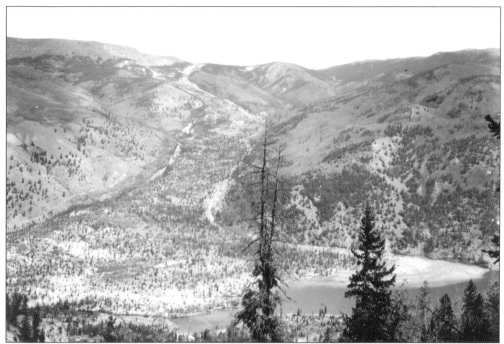

Slumgillion Slide. Caused by leaching around 1270 AD, the Slumgullion Slide, a huge earth flow, roared downhill and dammed up the Lake Fork of the Gunnison River, creating Lake San Cristobal, Colorado's second largest natural body of water. The slide still moves slightly today. (USGS.)

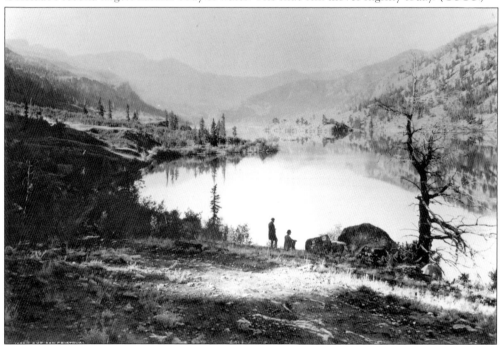

Early View of Lake San Cristobal. The famed photographer William H. Jackson took this early photograph of Lake San Cristobal in the 1870s. The picture was taken from the east side of the lake looking up the Lake Fork of the Gunnison River. (LCSW.)

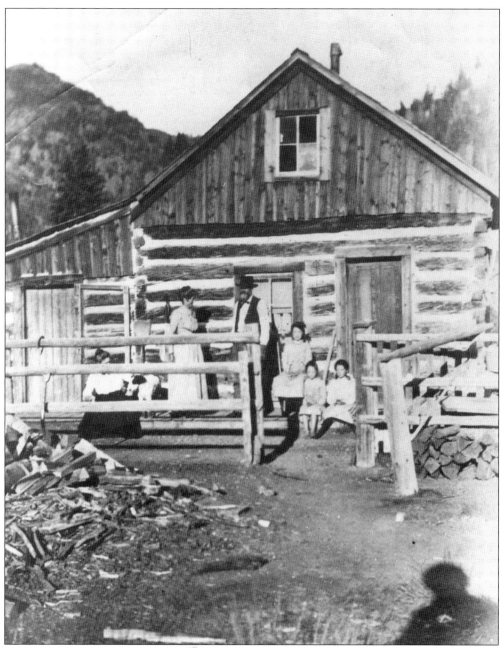

LAKE CITY AND BURROWS PARK PIONEER. Timothy Clawson, a Civil War veteran, shown here with his family, came to Lake City in 1876 and ranched and mined on the Upper Lake Fork and Burrows Park. Clawson took Lake City ores to the Centennial Exposition in Philadelphia in 1876 to promote the San Juan mining region. (LCSW.)

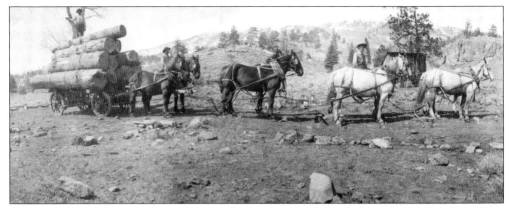

HAULING LOGS. An eight-horse team pulls a wagon loaded with huge logs below Lake City in 1900. The logs were taken to Kellogg's Sawmill nearby, where they were cut into railroad ties. (LCSW.)

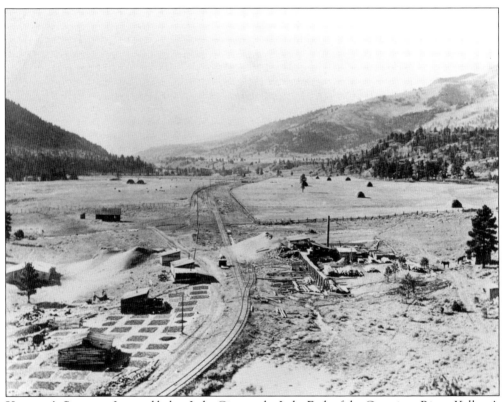

KELLOGG'S SAWMILL. Located below Lake City on the Lake Fork of the Gunnison River, Kellogg's Sawmill employed 15 men who turned out a constant stream of lumber for Lake City and its mines. Here, the mill is drying pine cones for reforestation. They sold for 50¢ a bushel. (LCSW.)

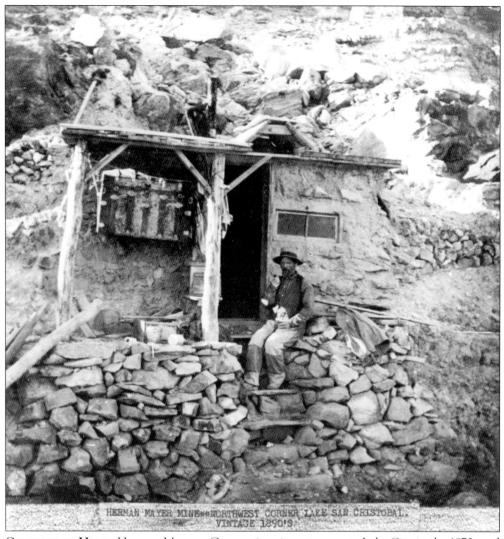

HERMAN MAYER MINE—NORTHWEST CORNER LAKE SAN CRISTOBAL.
VINTAGE 1890'S

COMFORTS OF HOME. Herman Mayer, a German immigrant, came to Lake City in the 1870s and established a ranch just below Lake San Cristobal. Mayer is sitting on the steps of his primitive home in 1891. (HH.)

THE GATE. This distinctive gate between Lake City and Gunnison was formed by the erosive activity of the Lake Fork of the Gunnison over millions of years. It remains one of the most important landmarks of early Lake City history. (USGS.)

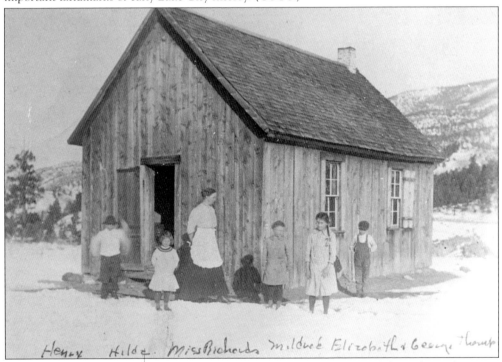

Henry Hilda. Miss Richards Mildred Elizabeth & George Thomas

YOUMANS. Youmans was named for Harry Youmans, an early pioneer of the Lake Fork region. The ranch-railroad siding was 11 miles below Lake City and was the final stop of the Lake City branch of the Denver & Rio Grande Railroad. Youmans had a section house, water tank, and corrals as well as a schoolhouse. Here, teacher Bertha Richards and her schoolchildren pose for a photograph around 1900. (HB.)

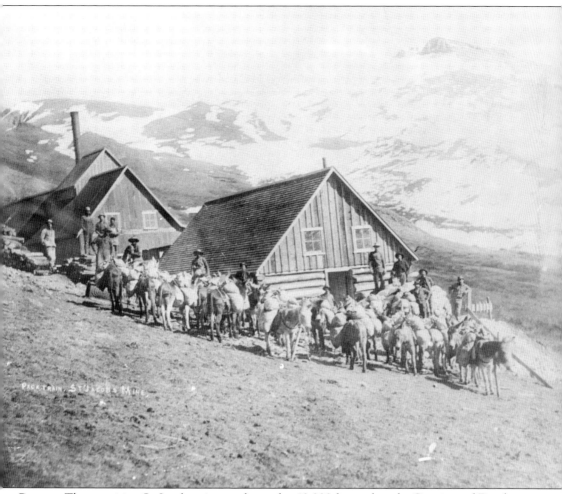

CARSON. The promising St. Jacobs mine was located at 12,000 feet and on the Continental Divide at Carson, west of Lake City and up Wager Gulch. A large pack train loaded with ore prepares to head down the gulch to a smelter. (RV.)

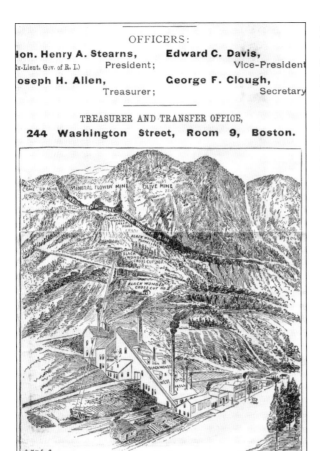

BLACK WONDER. This is an artist's sketch of the Black Wonder Mill and mine in 1894. The mining camp of Sherman is shown below. The gravity tram ran from the Black Wonder crosscut at a 20-degree angle to the mill below. Administration offices for the Black Wonder Mine were headquartered in Boston. (RK.)

GOLDEN FLEECE. On August 6, 1874, a toll road building crew headed by Enos Hotchkiss was building the Saguache–San Juan Toll Road over Engineer Pass and found rich gold high above Lake San Cristobal. The strike eventually became known as the Golden Fleece Mine and led to the start of the great mining camp of Lake City. (DPL.)

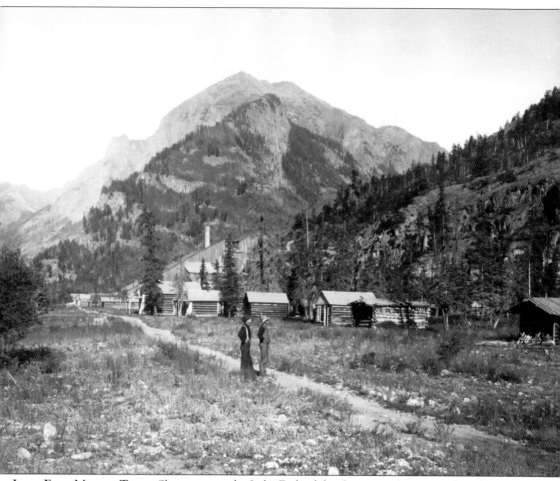

LAKE FORK MINING TOWN. Sherman, on the Lake Fork of the Gunnison River, was founded in 1876 because of the Black Wonder and other rich nearby mines. The mining town had a population of 200 and boomed in the late 1870s and early 1880s. (RK.)

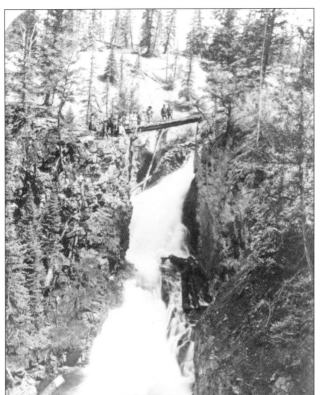

ARGENTA FALLS. A number of prospectors cross a bridge over 90-foot-high Argenta Falls in 1875. The beautiful falls on the Lake Fork of the Gunnison River were the location of the Minerva Mine, owned by the famed mine owner A.E. Reynolds. (LCSW.)

WHITE CROSS. Located at the west end of Burrows Park, White Cross was named for a geological formation in the shape of a cross. Posing at the post office in the mid-1890s, postmaster Harry Wright stands next to his son Clarence at left. His wife, Lena, and other son Rene are at center, and friend Fred Davidson is at right. (CW.)

BURROWS PARK, 1880. Named for early prospector Albert Burrows, this park included three mining camps along the Lake Fork of the Gunnison River, 17 miles west of Lake City. They were Tellurium (pictured), Argentum, and White Cross. All three camps began in the 1870s. Pictured here are the post office, general store, and hotel. (LCSW.)

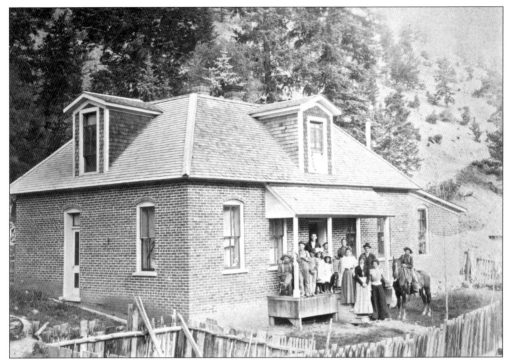

THE BAKER PLACE. This beautiful brick home was built by the Hunt brothers in 1891 for the Daniel and Virginia Baker family. Baker had one of the largest ranches in the entire region, dating to 1875. He raised cattle, hay, and a lovely garden. (FBH.)

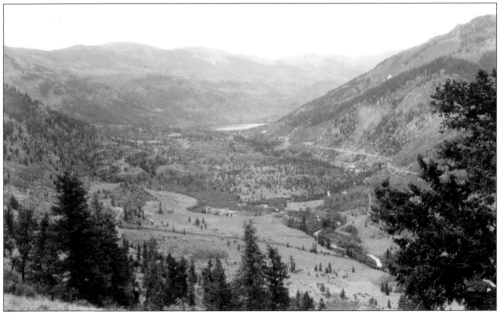

THE SLIDE AND THE LAKE. Taken in 1905, this photograph shows Lake San Cristobal and the lower end of the Slumgullion Slide, which created the lake around 1270 AD. The Lake Fork of the Gunnison River can be seen roaring downstream toward its junction with Henson Creek at Lake City. (USFS.)

Five

LAKE CITY RAILROAD

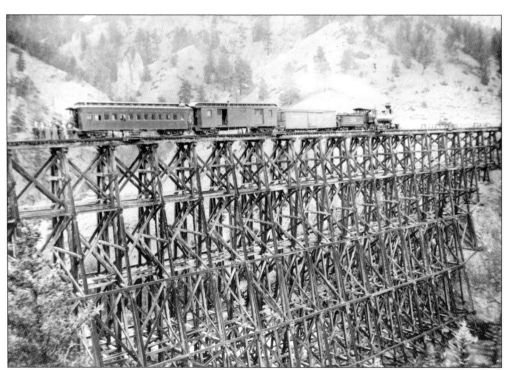

"GETTING HIGH" ON THE LAKE FORK BRIDGE. A Denver & Rio Grande passenger train pauses for a photograph on top of the famed High Bridge across the Lake Fork of the Gunnison River, six miles north of Lake City in 1892. The bridge was 800 feet long, and in the early years, nine-year-old Betty Steele was hired by the railroad to walk the tracks and pour water or sand on the wooden trestle to avoid a fire after the train had passed. (EBH.)

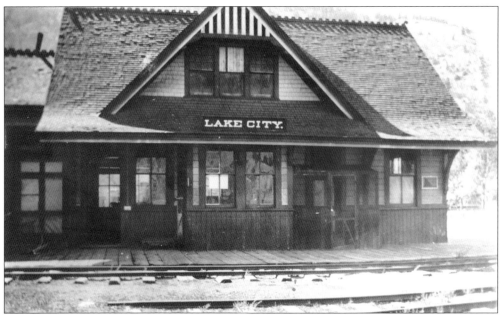

LAKE CITY DEPOT, 1920S. The beautiful Lake City Depot was part of the famed Denver & Rio Grande Railroad system. During the boom years of Lake City, thousands left the depot on a 37-mile branch line that connected to the main line at Sapinero. The depot was built in 1889 and demolished in 1937. (HCM.)

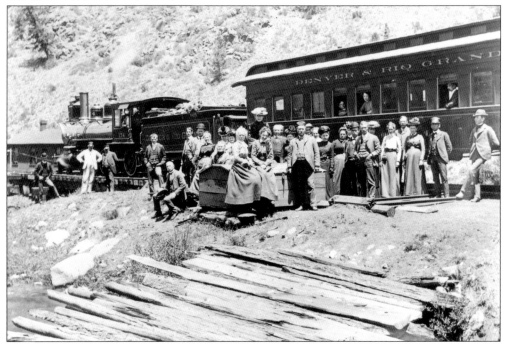

NARROW-GAUGE PHOTOGRAPHY STOP. This Denver & Rio Grande narrow-gauge train has stopped along the lower Lake Fork of the Gunnison River in 1894 for a photograph. With autos and good roads still in the distant future, rail traffic was the only reliable form of transportation then. (LCSW.)

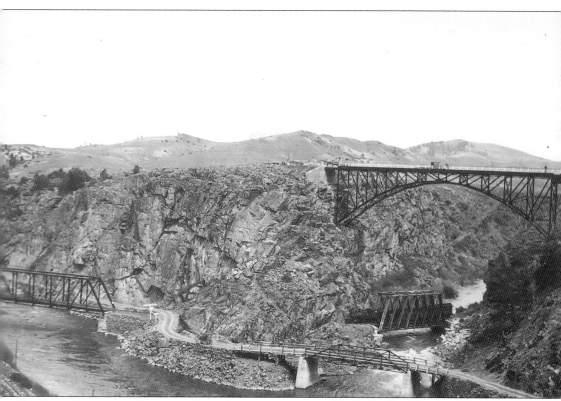

THE FOUR BRIDGES OF SAPINERO. One of the most famous railroad photographs ever taken, this view shows four bridges within yards of each other. These four bridges included a narrow-gauge railroad bridge and auto bridge from Lake City to nearby Montrose and two narrow-gauge bridges taking travelers from Sapinero to Lake City. Here, a Denver & Rio Grande train is crossing the Lake Fork of the Gunnison River in 1924. (RS.)

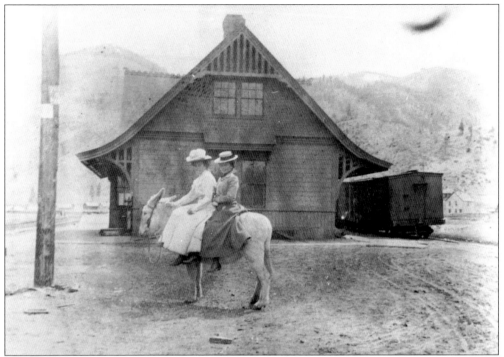

WAITING FOR THE TRAIN. Two Lake City women have ridden a burro to the Lake City Depot in 1898. They are waiting for the Denver & Rio Grande passenger train to arrive to take them to Gunnison. (BW.)

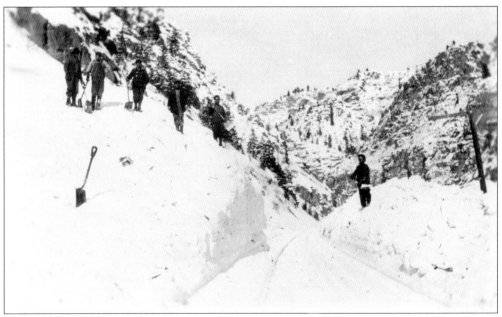

AVALANCHE. Workmen with shovels begin the laborious task of cleaning the railroad tracks after an avalanche in 1894. Avalanches were common in the Lake Fork Canyon south of Sapinero. Sometimes tracks were not cleared for days, thus shutting down all traffic. (RS.)

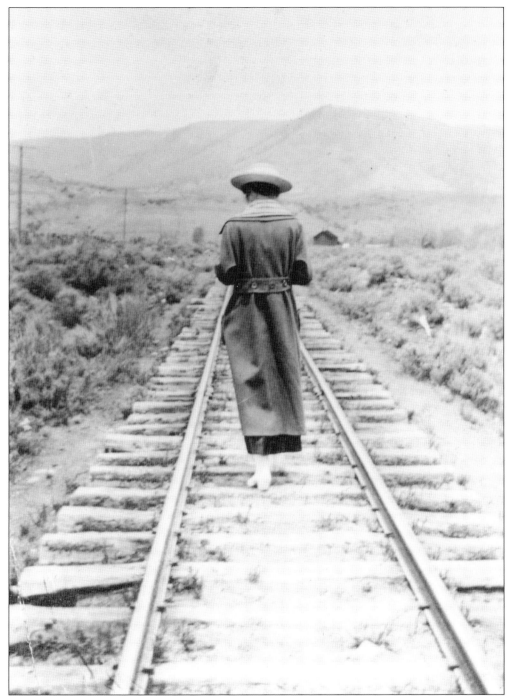

LATE TRAIN IN LAKE CITY, 1918. Lake City school teacher Ruth Milstead paces the railroad tracks as she waits for a three hour overdue Denver & Rio Grande train at Sapinero, 37 miles from Lake City. (CCP.)

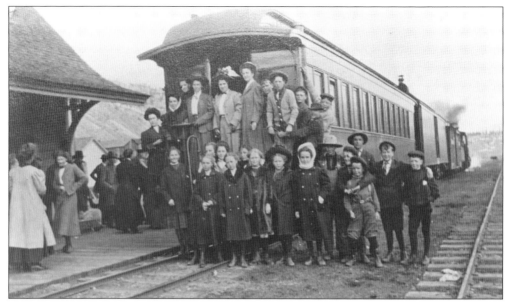

LAKE CITY EXCURSION, 1910. A group of Lake City schoolchildren and their teacher prepare to leave the Lake City Depot on a Denver & Rio Grande narrow gauge train. Both the children and teachers are dressed in their Sunday best for the much-anticipated trip to Denver. (CW.)

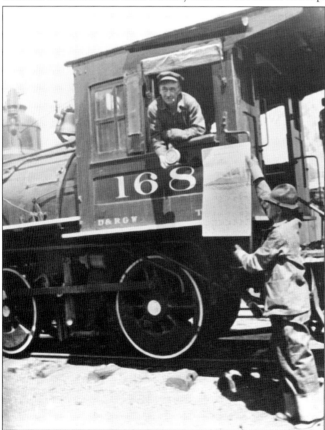

END OF AN ERA. Engine No. 168 prepares to leave Lake City with the last scheduled Denver & Rio Grande train. Fireman Sap Richardson leans from the cab with an alarm clock reading 2:30, and engineer Charles Freeman holds a calendar and points to the May 25, 1933, date. (LCSW.)

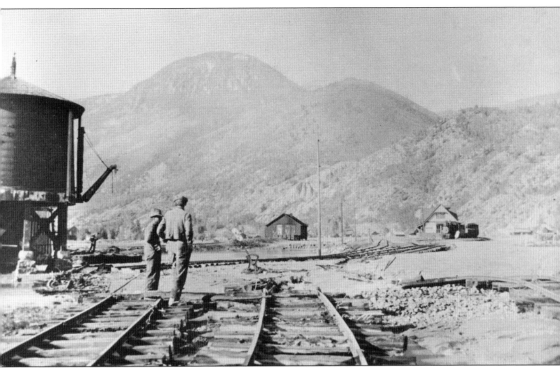

THE FLOOD OF 1921. Because of heavy snow in the mountains and abnormally warm days with rain, both Henson Creek and the Lake Fork of the Gunnison River flooded and merged at Lake City in June 1921. Both the water tank and depot were flooded, and the railroad tracks were undercut. (DV.)

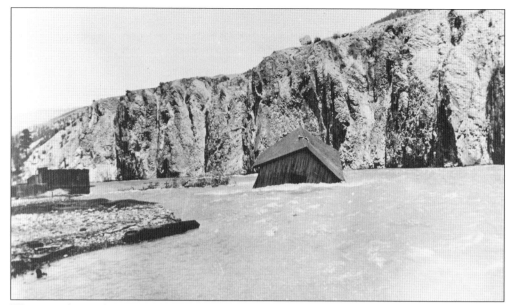

WASHING AWAY. A Denver & Rio Grande Railroad building washes away downstream as the Lake Fork of the Gunnison River roars over its banks in the disastrous flood of 1921. The flood was one of the worst in Lake City's history. (DV.)

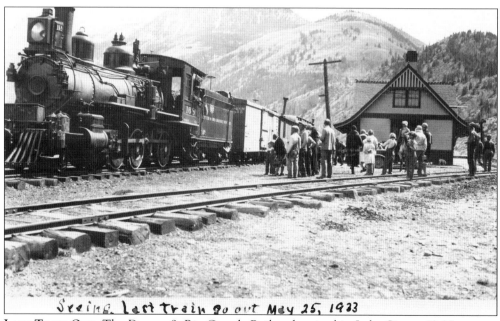

Seeing last train go out May 25, 1933

LAST TRAIN OUT. The Denver & Rio Grande Railroad arrived in Lake City at 10:00 a.m. on August 15, 1889. Here, distraught Lake City citizens come to see the last train out on May 25, 1933. An era had ended. (LCSW.)

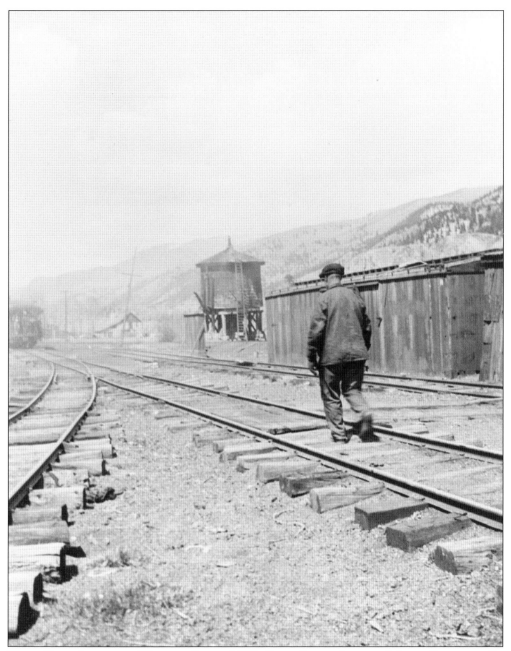

Hear That Lonesome Whistle Blow, 1933. Roundhouse foreman Johnny Benson walks dejectedly in May 1933 as the Denver & Rio Grande train leaves Lake City for the final time. The narrow-gauge railroad had serviced the once-booming mining camp for 44 years. (LCSW.)

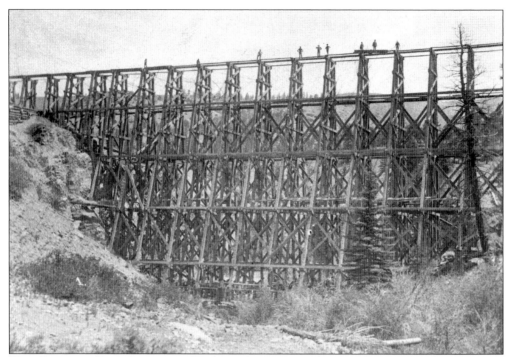

HIGH BRIDGE TO LAKE CITY, 1889. Workmen for Beam Brothers are shown in April 1889 putting the finishing touches on 350,000 feet of heavy spruce timber used in constructing the 800-foot-long, 113-foot-high Denver & Rio Grande Bridge north of Lake City (JBR.)

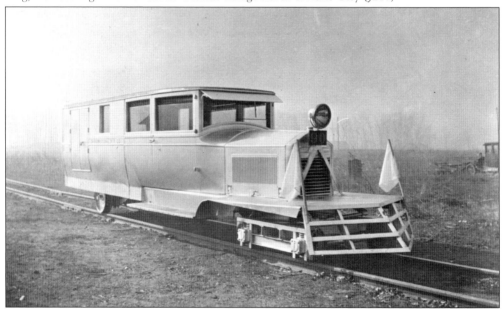

GALLOPING GOOSE, 1934. This unique and beautiful Pierce-Arrow automobile was fitted to run on Denver & Rio Grande narrow gauge railroad tracks between Lake City and Sapinero and was owned by Ute-Ulay Mine owner Mike Burke. The car was powered by an 80-horsepower Buick engine. The seven-passenger auto, which pulled cars behind it, was called the San Christobal Railroad and only ran from 1934 to 1935. (EB.)

Six

SURROUNDING CAMPS

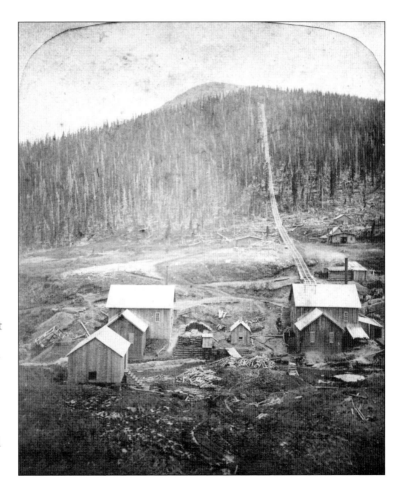

THE LITTLE ANNIE, 1875. Not far from Del Norte, Creede, and Slumgullion Pass, Summitville was the second oldest mining camp in the San Juan Mountains. The Little Annie mill processed gold ore via a long tram that ran from the mine. The Little Annie mine and mill eventually sold for $410,000. (LCSW.)

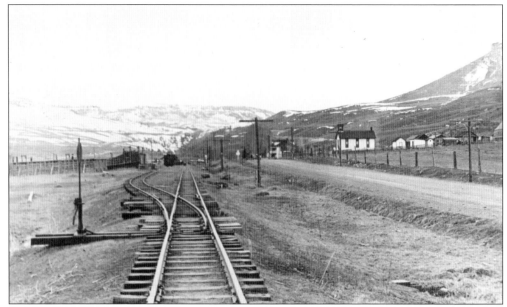

SAPINERO. Located at the junction of the Lake Fork and Gunnison Rivers and at the head of the Black Canyon west of Gunnison, Sapinero was a vital town in Lake City's history. It was here the 37-mile Lake City branch of the Denver & Rio Grande Railroad began, hauling supplies in and carrying ore out of Lake City. (DV.)

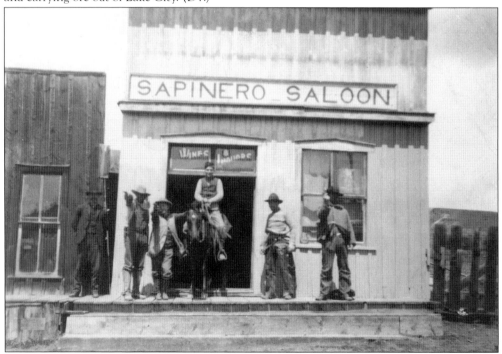

SAPINERO SALOON. Sapinero was on the main line of the Denver & Rio Grande Railroad and was a major shipping point. The town became a Rio Grande meal station and ranching center and was the scene of much excitement on weekends when ranchers, railroaders, and miners came together to drink, dance, party, and fight. (DV.)

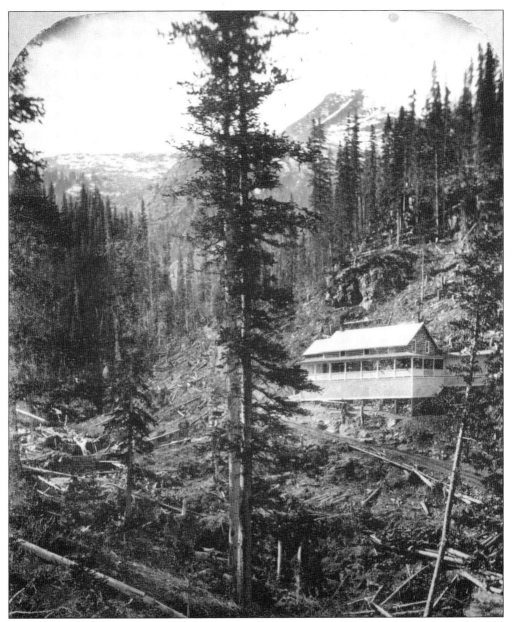

HIGHLAND MARY BOARDINGHOUSE. The Highland Mary mine was located up Cunningham Gulch, 1,000 feet up on a cliff above the gulch, seven miles from Silverton. It was considered one of the most promising mines of the San Juan but never panned out. Pictured here is the boardinghouse where the miners lived. (LCSW.)

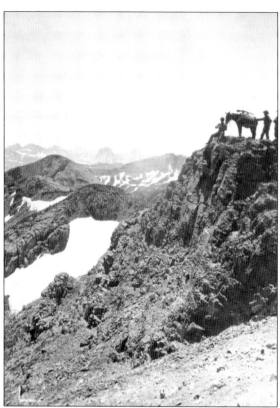

KING SOLOMON MOUNTAIN. Members of the Ferdinand Hayden surveying party gaze at the San Juan Mountains from the top of King Solomon Mountain in 1875. The Hayden Survey was one of four financed by the US government from 1867 to 1879 that conducted scientific surveys of the West. (USGS.)

ANIMAS FORKS. Located at 11,200 feet, Animas Forks was named for the two forks of the river that headed above the mining camp. Animas Forks had a 100-stamp mill to reduce its ore. The Gold Prince Mill measured 336 by 184 feet, and a 12,000-foot-long tram ran to it. The famed Silverton Northern narrow-gauge railroad took the Animas Forks ore down to Silverton. (BW.)

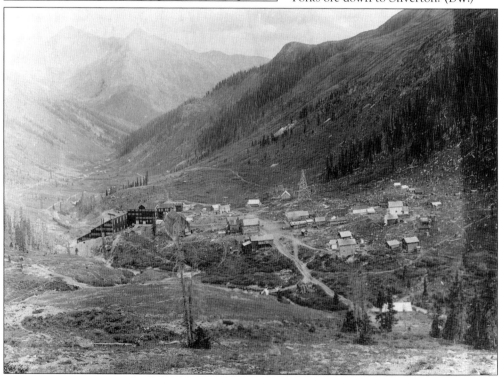

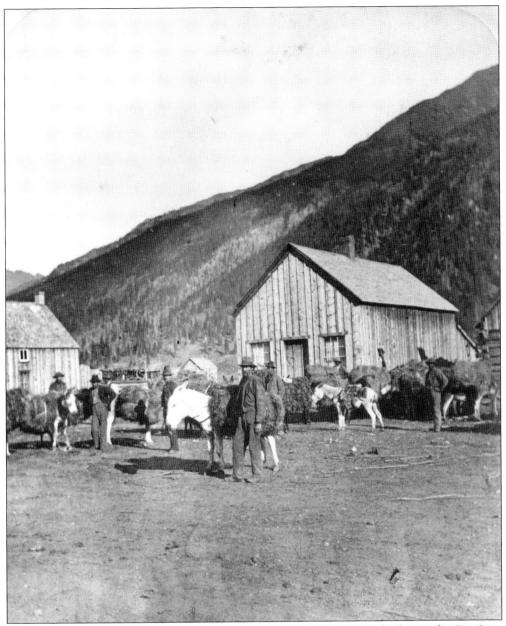

HAY TRAIN. Burros carrying hay arrive at Silverton heading for mines higher in the San Juan Mountains. The hay could not be grown at the high elevation of the mines but was the essential food for all the mules and burros working at the mines. (LCSW.)

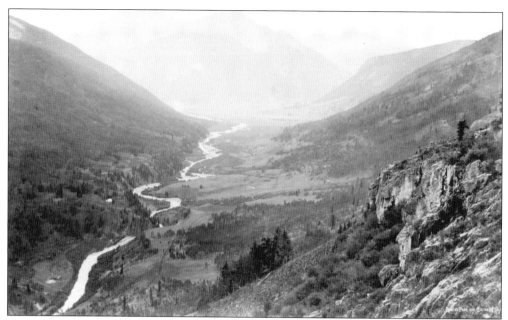

THE BEAUTIFUL ANIMAS, 1875. Heading above the mining camp of Howardsville, the beautiful and winding Animas River ran through Baker's Park to Silverton and then through the stunning Animas River Canyon to Durango before running into the San Juan River far downstream. Here, the Animas flows in 1875. (USGS.)

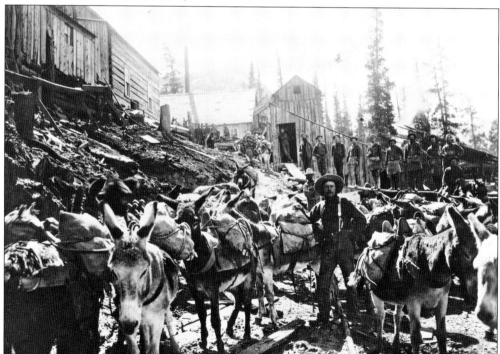

OLD LOT MINE. Miners and burros at the Old Lot mine in the mining camp of Poughkeepsie Gulch are ready to head out to other nearby mines with supplies. This beautiful gulch is on the west side of Engineer Pass and on a dangerous road that ran to Ouray. (HCM.)

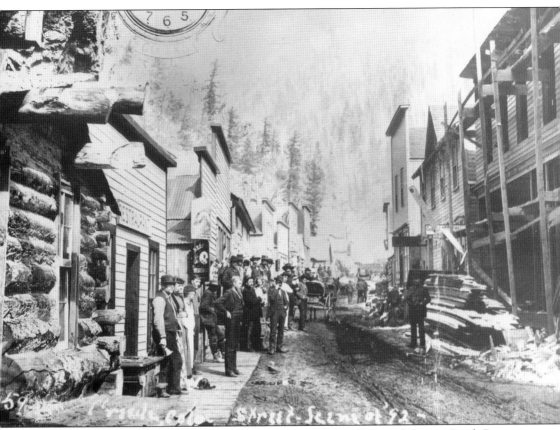

CREEDE, 1892. Located 52 miles from Lake City over Slumgullion and Spring Creek Passes, Creede, near the headwaters of the Rio Grande, became one of Colorado's greatest silver camps by the early 1890s. The booming mining camp surpassed 5,000 residents and turned out millions of dollars of silver before the Panic of 1893. (CHS.)

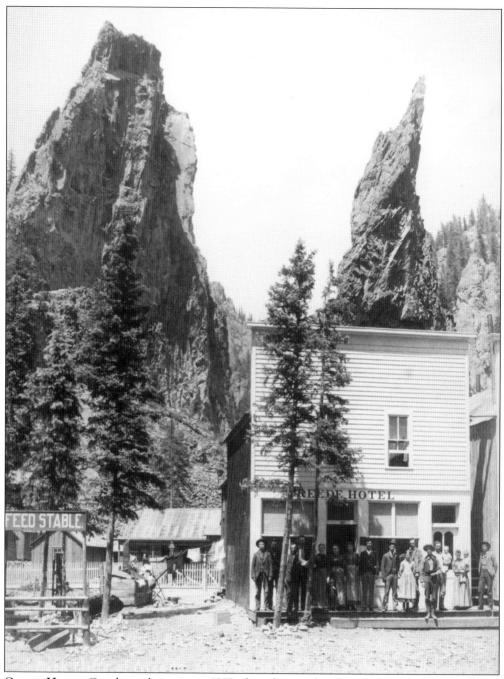

CREEDE HOTEL. Creede was booming in 1892 when this new hotel opened not far from the famed Amethyst silver mine. However, the silver panic of 1893 depressed the price of silver to 58¢ an ounce, and Creede, along with all other silver camps, collapsed. There would be revivals, but the great days were gone forever. (HCM.)

GARLAND CITY. The Denver & Rio Grande arrived in Garland City, the end of the line, in June 1877. Garland City was the base of operations for famed freighter Dave Wood, whose wagon trains carried supplies to nearby mining camps. By August, the town had a population of 300, and by 1878, it had 1,500 residents. By the end of 1878, Garland City was a ghost town, with its buildings moved to Alamosa, 24 miles to the west. (LCSW.)

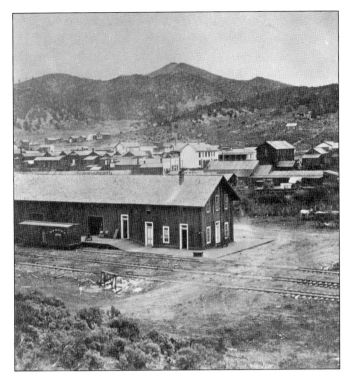

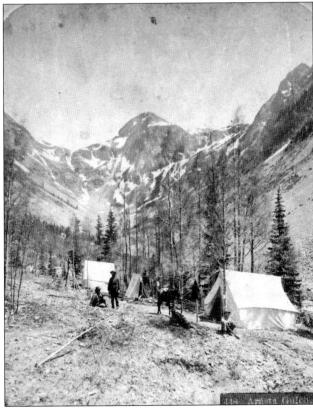

ARRASTRA GULCH, 1873. E.H. Ruffner's Reconnaissance in the Ute Country photographed miners beside their tents in Arrastra Gulch near the Animas River in 1873. The Ruffner expedition was looking for miners illegally trespassing on Ute Indian land. (LCSW.)

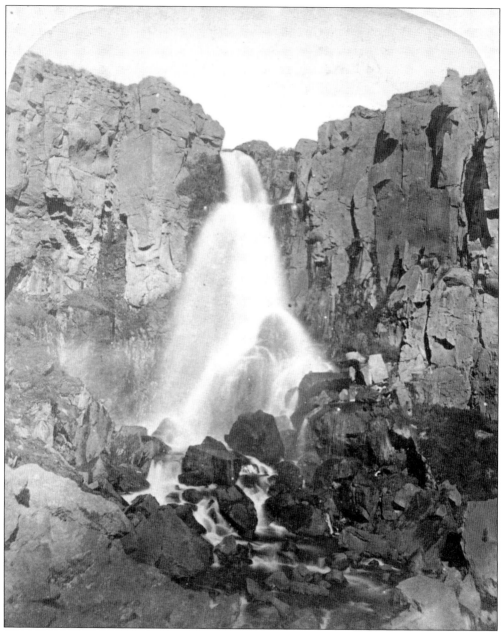

NORTH CLEAR CREEK FALLS. Located between Creede and Lake City, North Clear Creek Falls tumbles over 200 feet. The falls were a rest stop for early travelers heading deep into the San Juan Mountains in the 1870s and 1880s. (LCSW.)

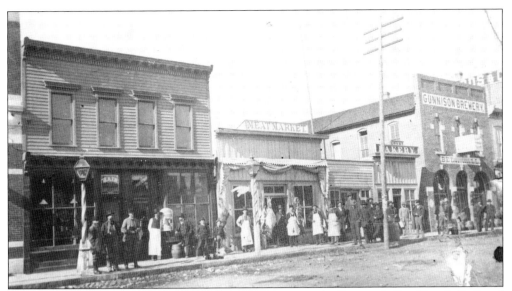

GUNNISON. 55 miles north of Lake City, Gunnison was on the Denver & Rio Grande Railroad mainline and was the jumping-off point to the many mining camps that surrounded it. The town grew to 5,000 people and was the top supply and railroad town of the region. (DV.)

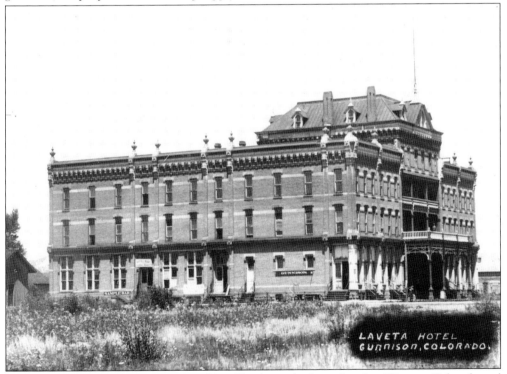

THE FAMOUS LA VETA. Gunnison's La Veta Hotel was the finest hotel in Western Colorado and one of the best in the state in the early 1880s. Four-and-a-half stories high and complete with gold lace, Persian rugs, and teak and mahogany, it was said to be "a peacock among mud hens." The hotel was built for $212,000, and Denver & Rio Grande Railroad tracks ran right in front of it. (DV.)

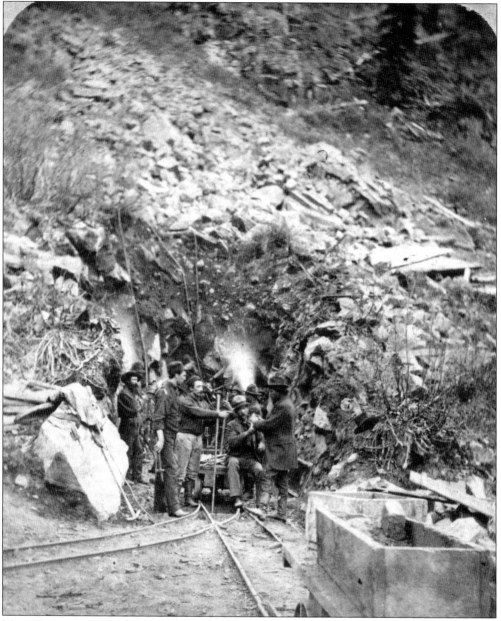

MAIN ENTRANCE. Highland Mary Miners pose with novel steam drills at the main entrance of the mine near Silverton in the 1870s. The main portal, like others in the San Juan Mountains, was driven in at an angle allowing mine cars to be pushed out by gravity. The mine was cold, dripped water, and was dangerous because of dust. (LCSW.)

Seven

Ain't We Got Fun?

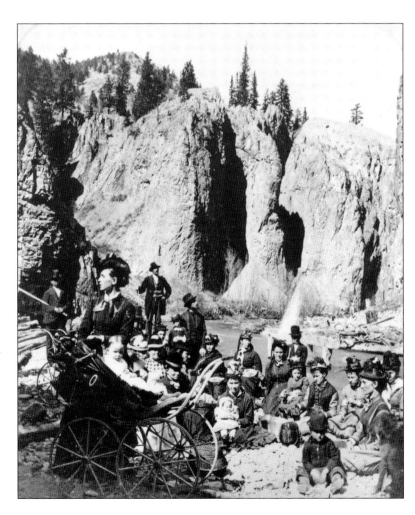

Picnic, 1878.
Lake City women
and children
escorted by four
men picnic on
the banks of
Henson Creek,
one mile west
of Lake City,
on a beautiful
summer day in
1878. (LCSW.)

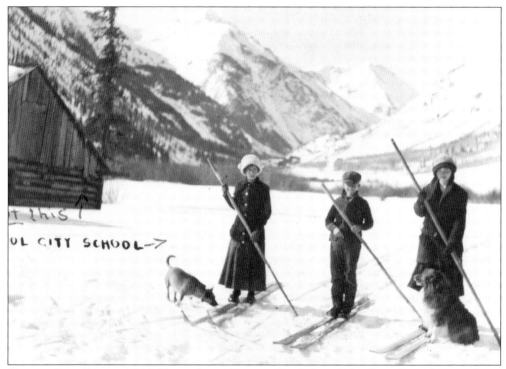

CAPITOL CITY SKIERS, 1916. Ten miles up Henson Creek from Lake City, three skiers and two dogs prepare for a day on the slopes. From left to right are Billy the dog, school teacher Alice Kelley, Thornton and Miriam Witherite, and Joe the dog. The skis are nearly 10 feet long, as are the guide poles. (FBH.)

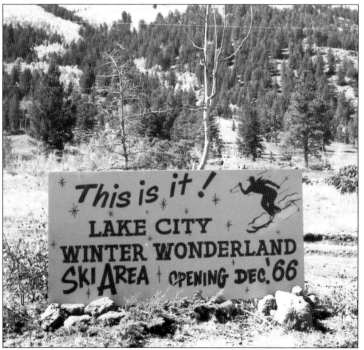

WINTER WONDERLAND. The Lake City Ski Area, with only a 300-foot vertical drop, opened in December 1966. The poma lift came from the Arapahoe Basin Ski Area. Therese Ryan was the driving force behind the ski area, as part of an effort to make Lake City into a winter mecca for outdoor enthusiasts. (HCM.)

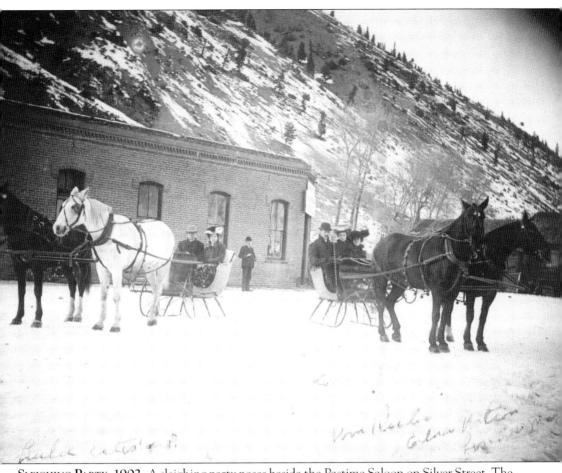

SLEIGHING PARTY, 1902. A sleighing party poses beside the Pastime Saloon on Silver Street. The woman in the sleigh on the left is Lulu Estes. In the other sleigh are, from left to right, William Keeler, Louise Mayer, and Edna Watson. Both sleighs are headed for Lake San Cristobal. (HH.)

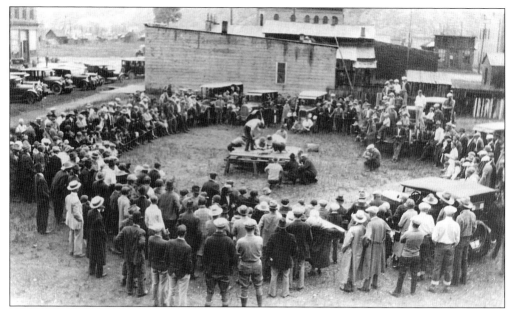

ROCK DRILLING, 1920s. Rock drilling was a much anticipated and highly competitive Fourth of July event in Lake City. Both money and pride were on the line, as miners from different camps competed against each other in single- and double-jack competition. (RV.)

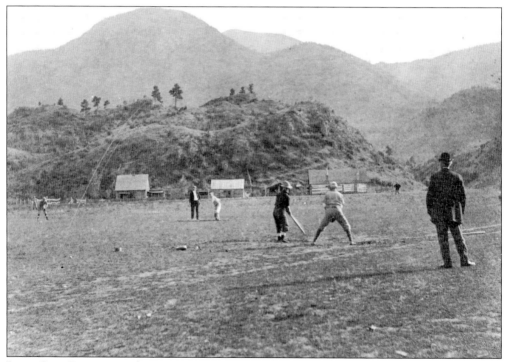

LAKE CITY BASEBALL. The Montrose Reclamation All-Stars are playing the Lake City Blues on September 3, 1911, on the Ball Flats just east of Lake City. The All-Stars defeated the Blues 17-11. (AH.)

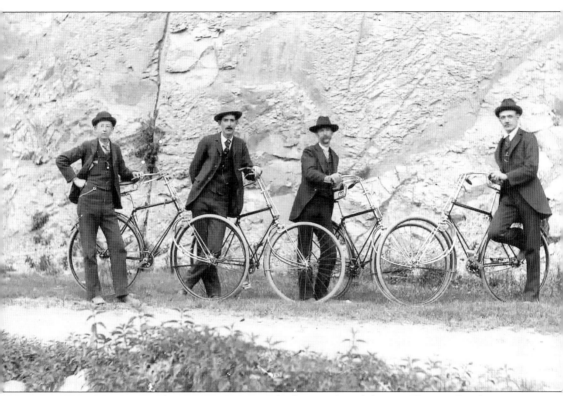

THE WHEEL CLUB. Four Lake City men pose with their "safety" bikes on Henson Creek near Lake City in the 1890s. The record time from Henson to Lake City, 4.3 miles, was 16 minutes by wheel club members—very fast considering the poor condition of the road. (RK.)

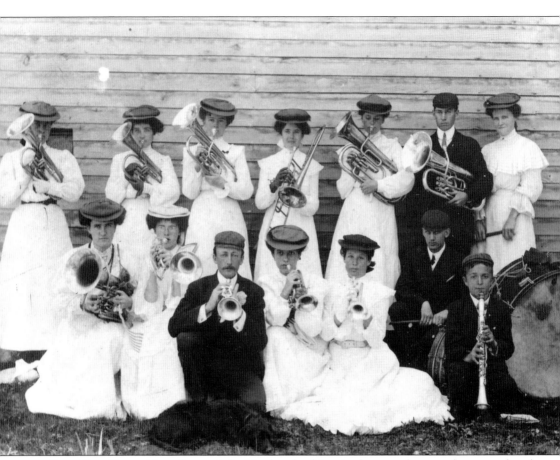

LAKE CITY BAND. One of many Lake City bands, this mixed group of men and women played at the opening of the Gunnison Tunnel on September 23, 1909, in Montrose, Colorado. The tunnel diverted water from the Gunnison River in the Black Canyon to the Uncompahgre Valley; it was the first major Bureau of Reclamation project in history. Pres. William Howard Taft threw the switch that released water into the valley. (AK.)

LAKE CITY GREENS, 1920.
The Lake City Greens basketball team, Western Slope champions, have just taken the measure of Gunnison. Team member John Milne (far right) penned the following: "With the stope-wrench and the moil, Gunnison's record we did spoil." (AED.)

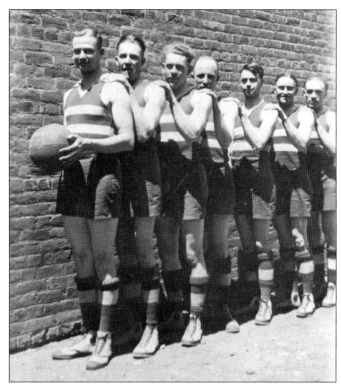

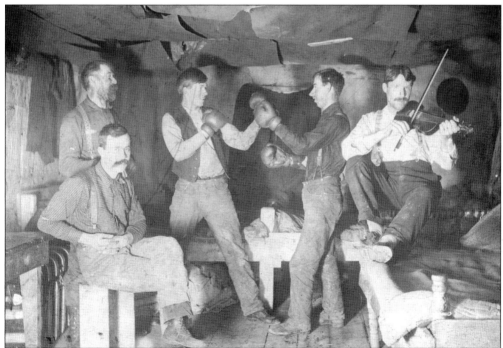

MIXING IT UP. Miners at Sherman along the Lake City Fork of the Gunnison River, 10 miles from Lake City, have a rare day off and entertain themselves in their cabin near the turn of the 20th century. Heavy betting on boxing matches was common in Sherman on weekends. (BW.)

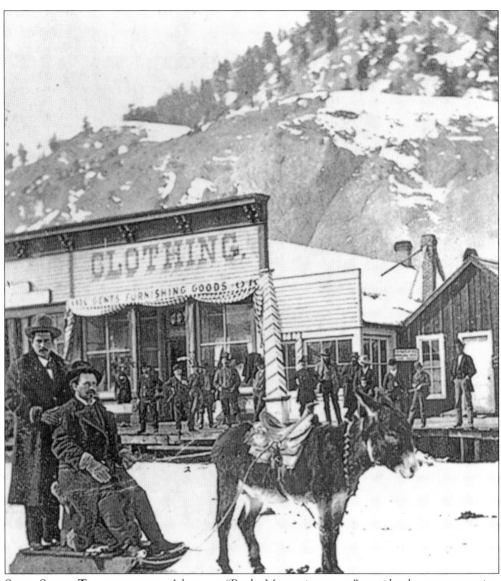

Silver Street Transportation. A burro, or "Rocky Mountain canary," provides slow transportation via sled for two Lake City men on Silver Street in 1882. In the background is a clothing store owned by Louis Kefka and a barbershop. (LCSW.)

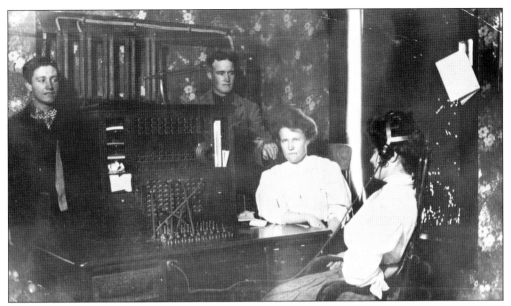

EARLY TELEPHONE SWITCHBOARD. Two women telephone operators are pictured at their stations in Lake City in 1910. The first telephone system was put in Lake City in 1881 and was connected with nearby mining camps in the San Juan Mountains. Everyone was on a party line and able to listen to music during special concerts over the line from the nearby camps. (HCM.)

BEAR HUNT. This huge black bear was trapped by George Thompson in the San Juan Mountains near Lake City in 1925. When the bear was put on the burro, the weight was too great, and the burro collapsed. Immediately after this photograph was taken, the bear was taken off the burro's back. (FBH.)

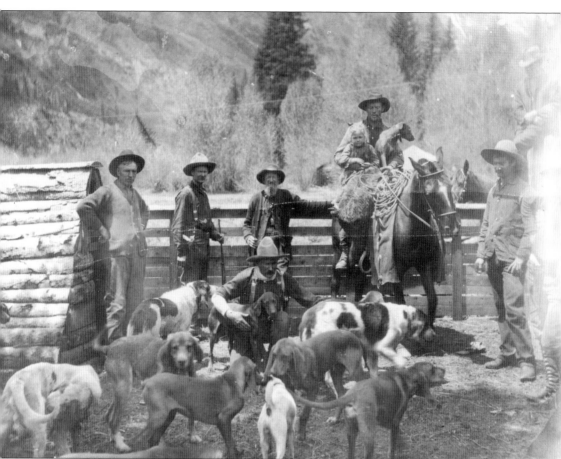

HUNTING PARTY, 1910. A Lake City hunting party prepares to head out on a mountain lion–bear expedition from near Sherman on the Lake Fork of the Gunnison River. Both dogs and men are excited to challenge tough foes. (AK.)

THE OCCIDENTAL. The Occidental Hotel was located on Silver Street and was one of the earliest hotels in Lake City. The hotel had 20 rooms and was in the process of enlarging in 1897 when it was destroyed in a fiery blaze. (JC.)

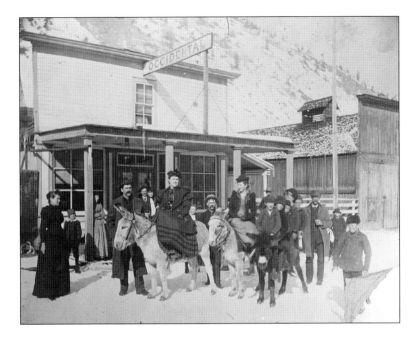

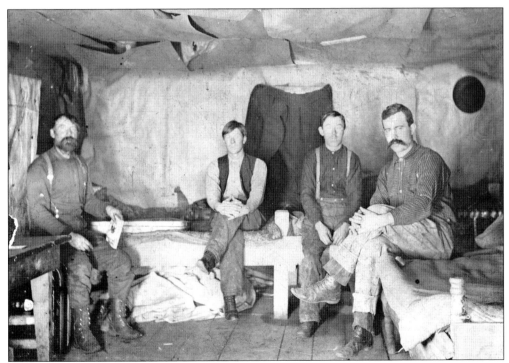

REFLECTING AT THE END OF A HARD DAY. Four miners at Sherman have finished work for the day and relax in their rustic cabin, reflecting on their lives in a mining camp. The miners worked hard and played hard. (BW.)

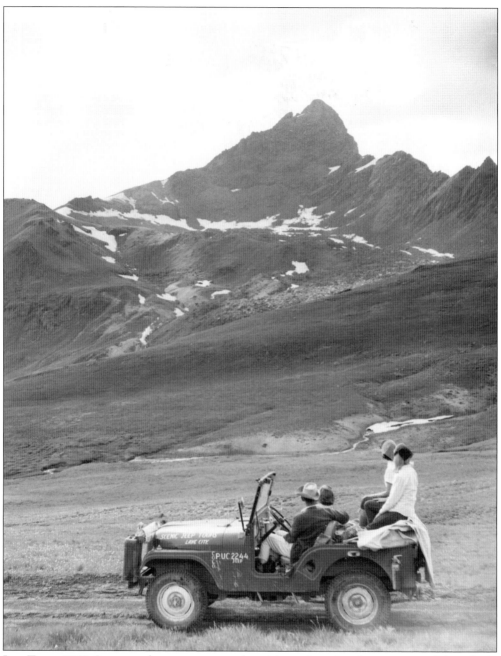

JEEP TOUR, 1962. Jeep tours became very popular with tourists after the invention of the vehicle in World War II. Here, a Scenic Jeep Tours four-wheel drive vehicle is in action with 14,000-foot Mount Wetterhorn in the background. The area is now part of wilderness land, and mechanized vehicles are prohibited. (AG.)

Eight

POTPOURRI

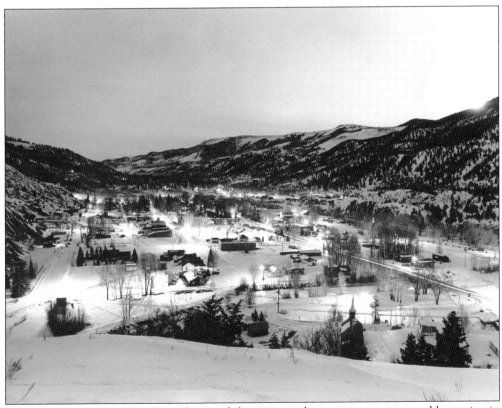

LAKE CITY SPLENDOR. The sky is clear, and the moon is about to rise on a very cold morning in Lake City in 1989. The light shows the incredible beauty of a nearly 9,000-foot-high San Juan mining town with a glorious past. (BS.)

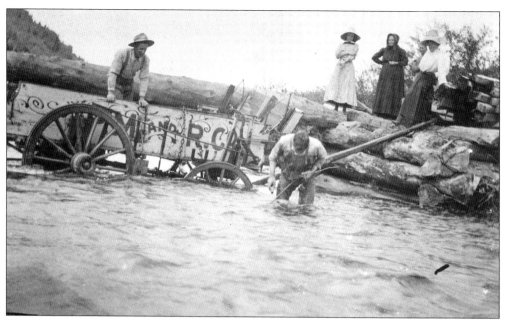

RIVER CROSSING. Orville (left) and Tony Baker are stuck in the Lake Fork of the Gunnison River below Lake City around 1900. Stream crossings were always a difficult proposition when rivers ran high in the spring of the year. (FBH.)

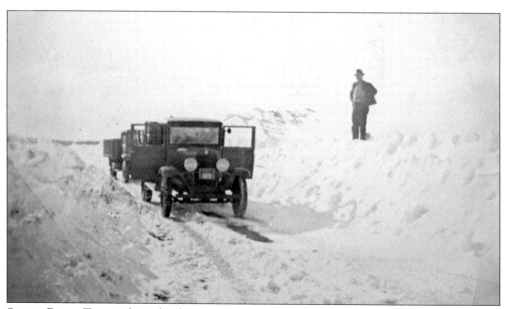

SNOWY ROAD. Two trucks make their way slowly along a road that has just been plowed out on Goose Creek Flats near the old gold camp of Dubois north of Lake City on February 28, 1936. Charles Harkness is the man on the snowbank surveying the scene. (JMS.)

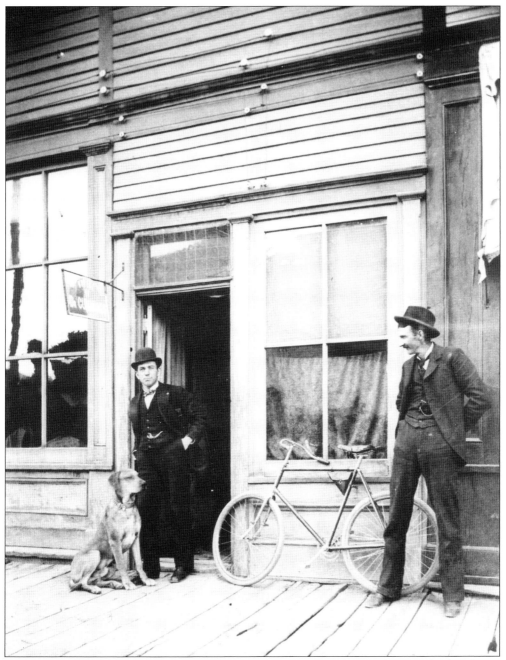

DR. CUMMINGS. Dr. Benjamin Cummings (left) poses in front of his newly opened Silver Street office in 1898. His assistant is Shorty Myers, and the dog is Jim. Dr. Cummings visited his patients on his sturdy bicycle. (MCB.)

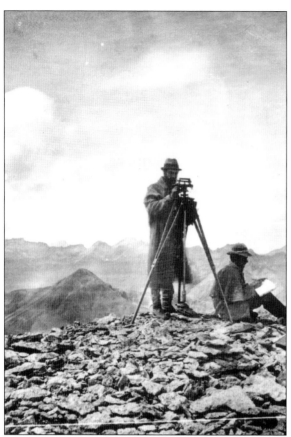

TRIANGULATION. H.D. Wilson (standing) and Franklin Rhoda, members of the Hayden Survey team, are engaged in triangulation on top of Sultan Mountain near Silverton in 1874. The Hayden Survey covered the emerging mining country of the San Juan Mountains in the 1870s. (USGS.)

HOUGH FIRE COMPANY. The Hough Fire Company poses for a photograph on the corner of Gunnison and Third Streets in Lake City in 1905. The two men in front are Charles Forberg (far right) and Guy Harkness. Fires were always a problem in Lake City and other mining camps, where most of the buildings were made of wood. (DV.)

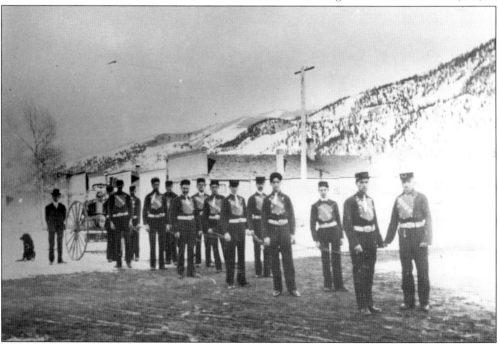

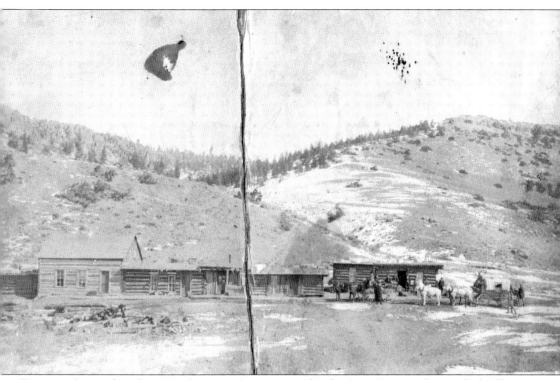

BARNUM. Located in the 1870s between Gunnison and Lake City, Barnum, later called Allen and Gateview, was a halfway house for travelers. Barnum had a store and a post office and was a stopping place until the arrival of the Denver & Rio Grande Railroad in 1889. The Lake City Stage can be seen, with four horses providing the power. (LCSW.)

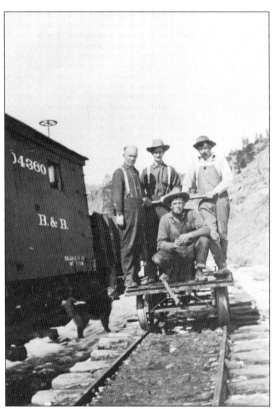

CHECKING THE RAILS. Denver & Rio Grande workmen rest on a rail car while running a safety check on the rails between Lake City and Sapinero in 1920. The photograph was taken at Spruce Siding north of Lake City. Earl Disney is the man kneeling in front. (DV.)

DRESSED UP. The John S. Hough Fire Company poses in front of a downtown Lake City building in 1905. John Hough financed the company and was a candidate for Colorado governor in 1880; he also was the second cousin of Ulysses S. Grant. Hough was known for grubstaking miners of the Lake City area. (AK.)

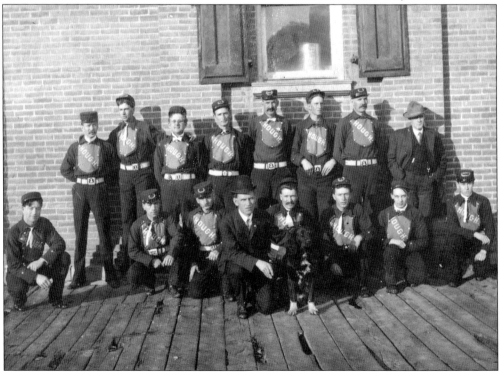

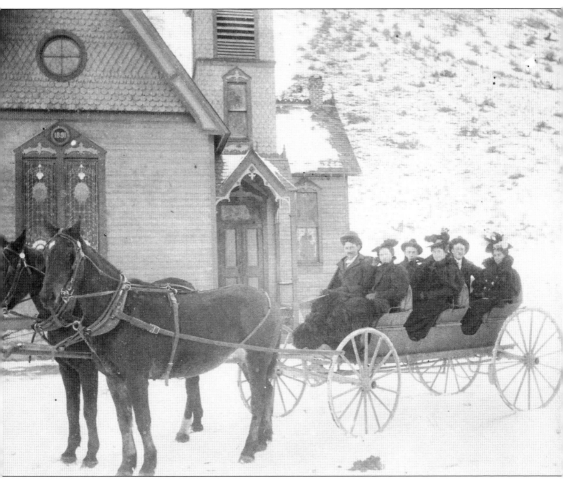

Bundled Up. A group of Lake City men and women are bundled up during a cold winter morning in Lake City in 1901. The Baptist church is in the background, and Louise Mayer is the young woman in the back of the carriage. (HH.)

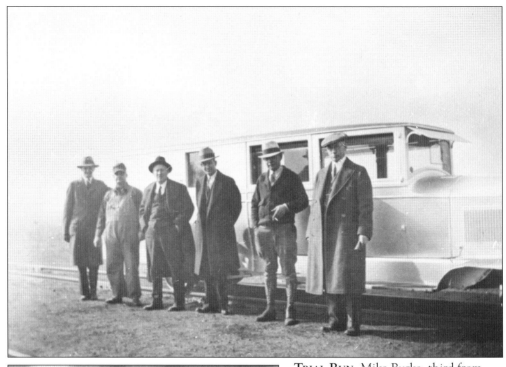

TRIAL RUN. Mike Burke, third from left, owned the Ute-Ulay mine at Lake City. When the Denver & Rio Grande Railroad stopped running to Lake City, Burke started the San Cristobal "Galloping Goose" railroad to replace it. Here, Burke is with inventors and a railroader driving the train during the trial run of the San Cristobal in 1934 in Denver. (EB.)

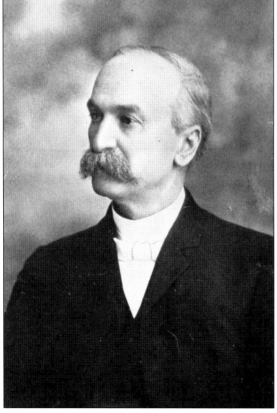

GEORGE DARLEY. Pioneer Presbyterian missionary George M. Darley traveled on skis, foot, and horseback throughout the San Juan Mountains in the 1870s, bringing religion to the miners. Father Darley wrote about his experiences in *Pioneering in the San Juan*. (LCSW.)

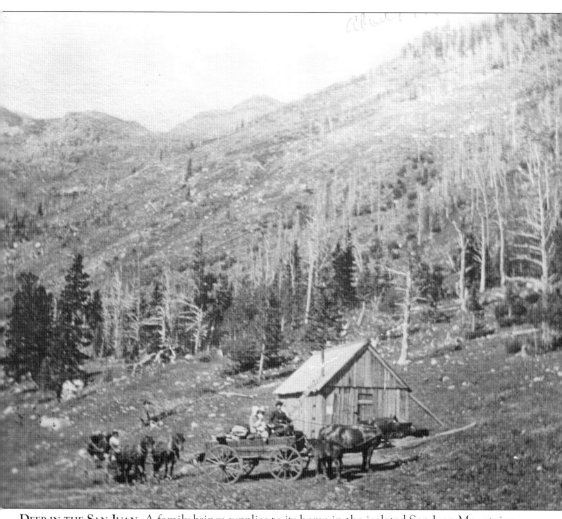

DEEP IN THE SAN JUAN. A family brings supplies to its home in the isolated San Juan Mountains in 1917. Above the cabin, trees have been clear-cut, leading to high avalanche danger. (DV.)

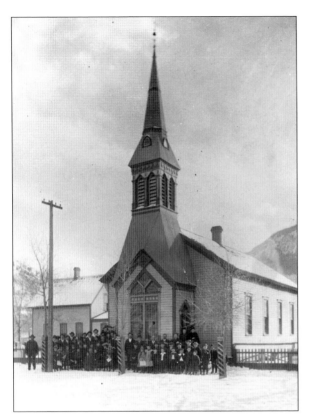

SUNDAY SCHOOL. Young boys and girls with their parents are in their Sunday best as they prepare for Sunday school at the historic First Presbyterian Church in Lake City in 1898. (CHS.)

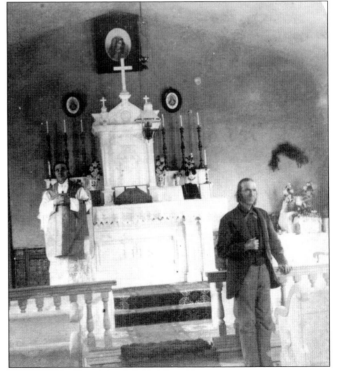

CATHOLIC MASS. Father Hayes conducts mass at the St. Rose of Lima Catholic Church in Lake City in 1877. The church was the first Catholic church on the Western Slope of Colorado. The altar in the background was locally made and remains in the church today. (LCSW.)

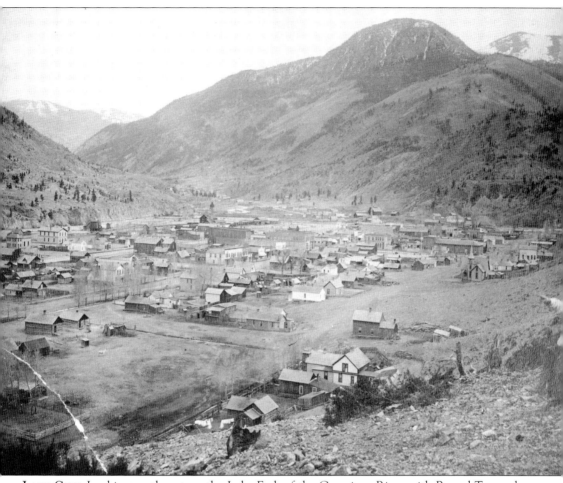

LAKE CITY. Looking southwest up the Lake Fork of the Gunnison River with Round Top and Red Mountains in the background, Lake City is peaceful and serene after the booming mining days of 20 years earlier. (BW.)

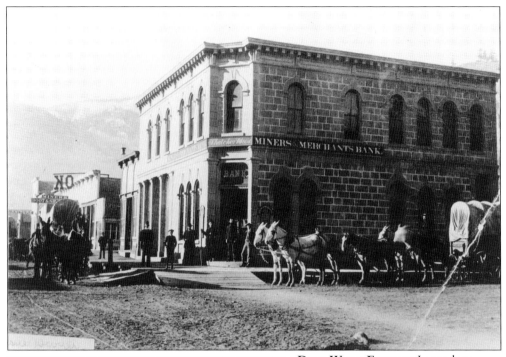

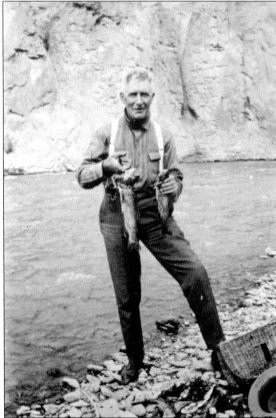

DAVE WOOD FREIGHT. Legendary freighter Dave Wood's freight wagons bearing supplies for Lake City are stopped on both sides of the Thatcher Brothers Miners and Merchants Bank in 1882. Wood's daughters later wrote of Wood's colorful life in *I Hauled These Mountains in Here*. (LCSW.)

GOOD FISHIN'. Early Texas seasonal resident Richard Wupperman enjoyed good fishing on the Lake Fork of the Gunnison River in the 1930s. The Denver & Rio Grande Railroad would drop Wupperman off in the morning and pick him up in the evening with his catch of fish. (LCSW.)

Nine

LAKE CITY MEMORIES

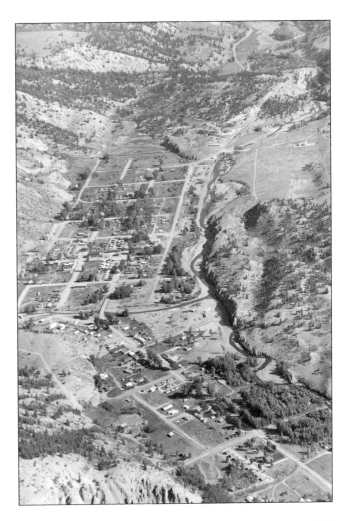

FROM THE AIR. This is a 1960s aerial photograph of Lake City shows the quadrangular layout of the town and also the merging of Henson Creek with the Lake Fork of the Gunnison River. The photograph looks north; in the upper right are the Ball Flats, where many exciting baseball games were played involving the Lake City Blues. (LCSW.)

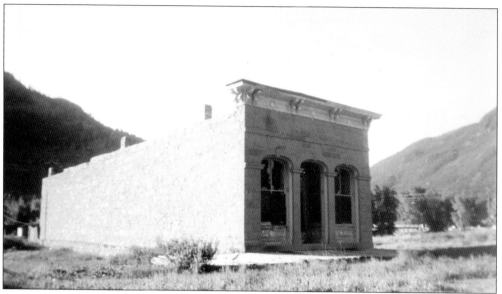

HINSDALE COUNTY MUSEUM. This fine sandstone building was built in 1877 as a general merchandise store, the Stone Trade Palace. The building became the Odd Fellows Lodge and then was abandoned and fell into ruin by the late 1940s. It has since been beautifully restored as the Hinsdale County Museum. (DPL.)

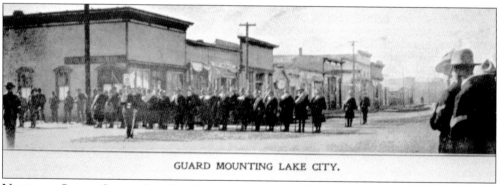

GUARD MOUNTING LAKE CITY.

NATIONAL GUARD CALLED IN. The Western Federation of Miners struck the Hidden Treasure Mine on Henson Creek in March 1899. The Union broke into the armory in Lake City and stole rifles, which led to the calling out of the Colorado National Guard. The Italian Consulate was called in and negotiated a truce. The Italians who had struck were summarily fired. (LCSW.)

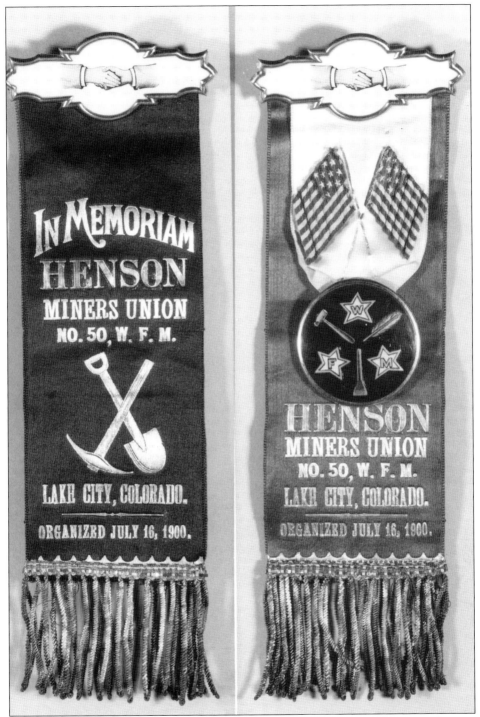

WESTERN FEDERATION OF MINERS. The top labor union in the West, the Western Federation of Miners played an important role in Lake City. The union fought for the rights of miners and was involved in many violent strikes in Colorado, including one in Lake City in 1899. Pictured are membership ribbons of the WFM. (WE.)

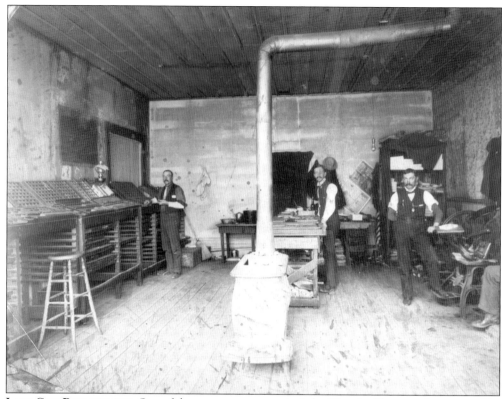

LAKE CITY PHONOGRAPH. One of the many newspapers in Lake City, the *Phonograph* was a weekly. The paper was housed in the La Veta Hotel Block on Third Street. In this photograph are, from left to right, D.C. Louden, W.C. Blair, and John Uglow, publisher. (JBR.)

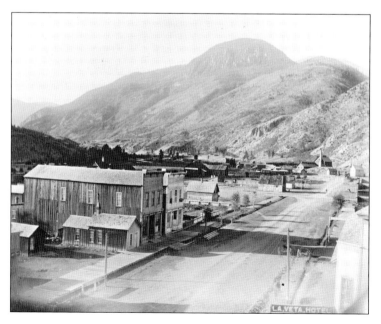

GUNNISON AVENUE. Lake City was going downhill in 1900. Mining had collapsed with the silver panic of 1893, and most mines of the area had closed. On the right is the Van Giesen Lixivation Works, and at lower right, the La Veta Hotel can be seen. (LCSW.)

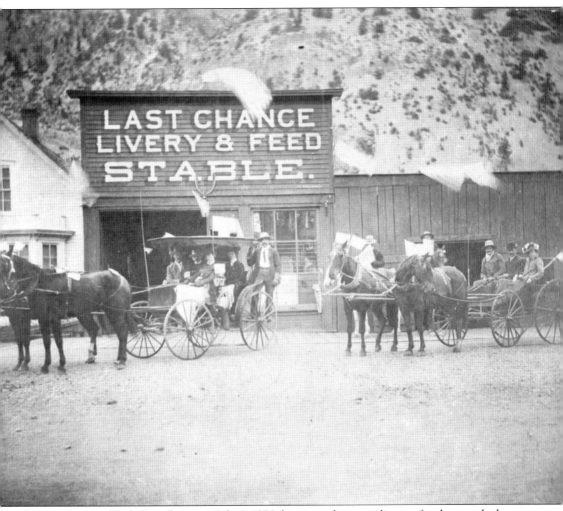

LIVERY STABLE. With flags flying on July 4, 1898, horses and wagons line up for the parade down the main street of Lake City. In the background is the Last Chance Livery & Feed Stable, one of many in town. John Addington, the owner, stands in front of the building. He was killed in 1901 in a gunfight in Lake City. (LCSW.)

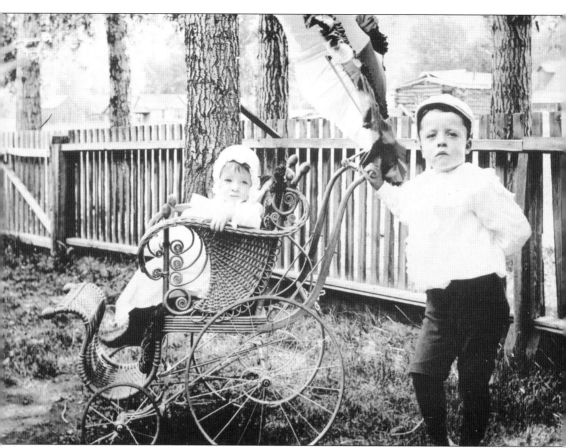

Youngsters of Lake City. Baby Stanley, two years and two months old, and Chester, four years and six months old, pose for a photograph on Bluff Street on July 25, 1900. Both were sons of pioneer merchant George J. Richards. Chester looks like he is "the man of the house." (LCSW.)

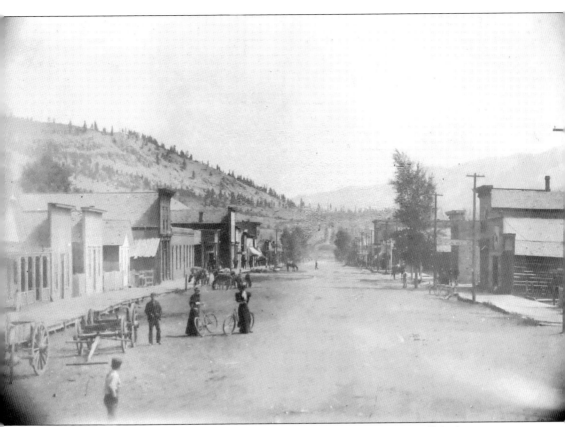

LAKE CITY, 1895. Lake City, despite the silver panic two years earlier, was still fairly prosperous in 1895. Silver Street was one of the many wide streets to allow for mining traffic. Featured in this tranquil afternoon scene are pedestrians on the board sidewalks, a horse casually grazing, and two women bicyclists. (RK.)

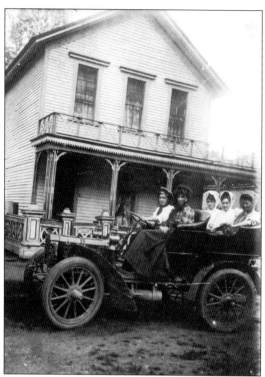

Peerless Auto. Lake City's first automobile was a 1903 two-cylinder Peerless that was bought by Golden Wonder Mine owner Thomas L. Beam in 1907. The auto, with rear door access and a top speed of 42 mph, had a ticket price of $1,750—equivalent to $39,830 in today's currency. The car is pictured in 1907 driven by Edna Beam. Other passengers include Florence Uplow (next to Edna), and in the back seat, from left to right, Esther Travis, Ruby Fairis, and Carolyn Hunt. (MCB.)

Fire Holocaust. On Christmas Eve 1913, a fire broke out in the Corner Saloon on Silver Street in Lake City. Miraculously, adjoining buildings survived. Spectators dragged whatever they could out of the building and into the street. (VRB.)

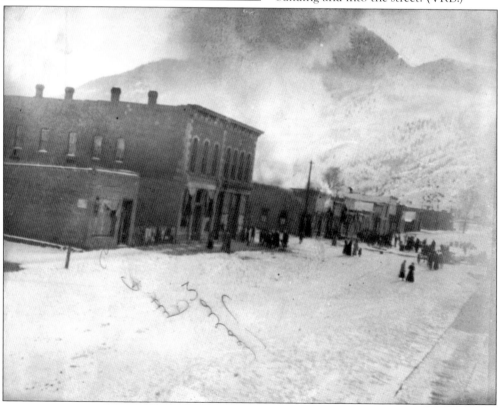

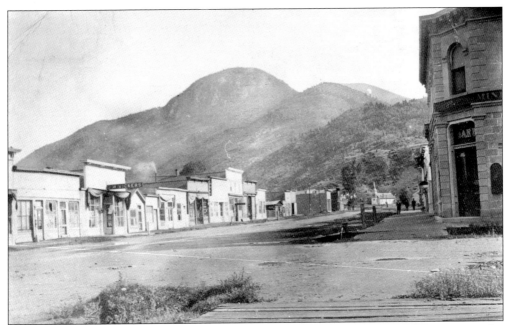

SILVER STREET, 1911. The great days of Lake City were in the past in 1911. Grass grew in the streets, many mines had closed, and the population dwindled. Four years later, all the buildings across from the bank burned down. (AH.)

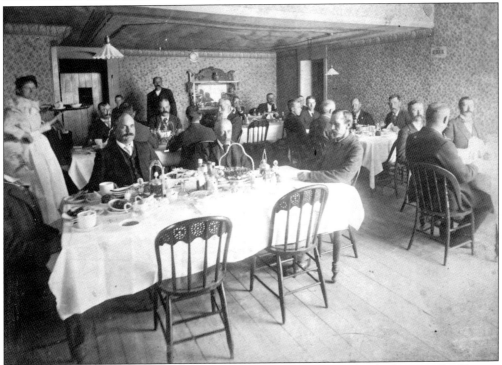

DINNER AT THE OCCIDENTAL. Well-dressed Lake City businessmen gather for dinner at the 40-room Occidental Hotel at Fourth and Silver Streets in 1900. The original Occidental across the street burned in 1897. This great Lake City hotel burned down in 1944. (AK.)

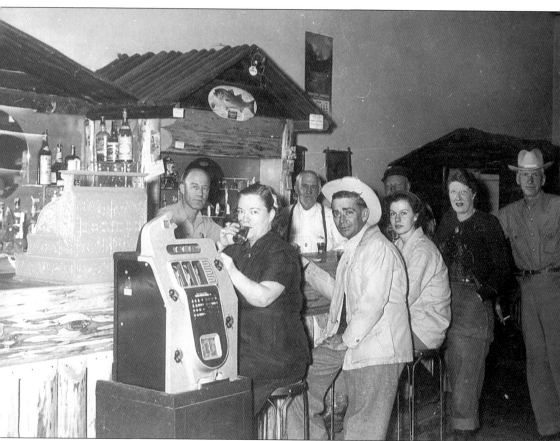

THE LOG CABIN. One of the two top bars in Lake City was the Log Cabin, which drew patrons with a restaurant, libations, and slot machines. Each of the eight booths in the establishment was a miniature log cabin complete with doors and windows. Owner Jack Milner is behind the bar on the left, and his wife, Ethel, is seated next to the slot machine. (SLV.)

DANCING AT THE ELKHORN. Owner Wesley West, a former boxer, dances with Evelyn Ward at his cocktail lounge in 1953. West introduced a roulette wheel and slot machines to Lake City. (MD.)

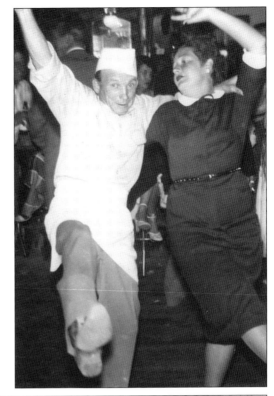

FRATERNAL GATHERING. Men and women gather in the upstairs of Lake City's IOOF Lodge, Silver Star No. 27, in the late 1890s. This lodge was the first secret order on the Western Slope, dating to 1876. (JBR.)

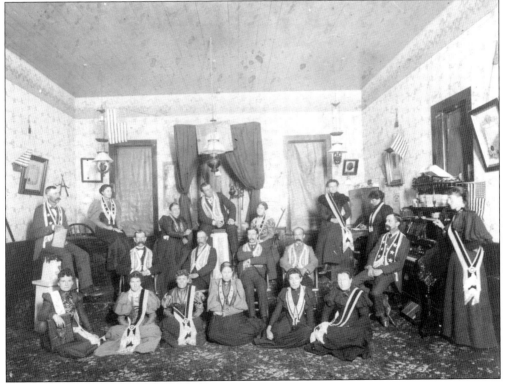

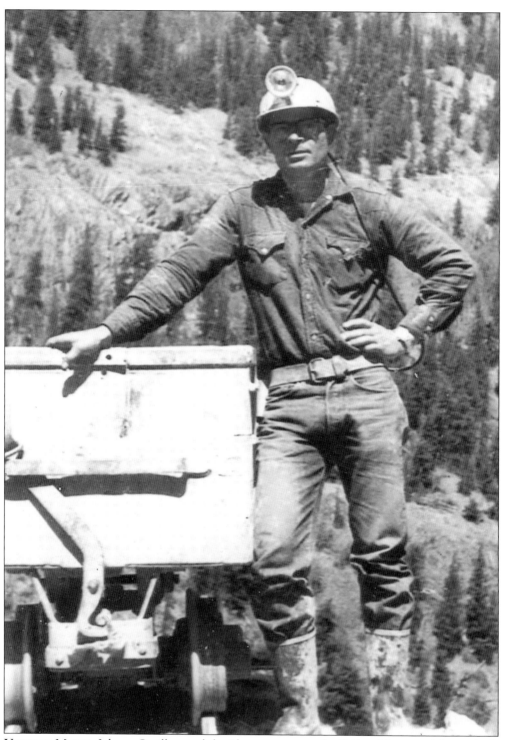

VETERAN MINER. Johnny Saville stands beside an ore car at the Pride of America Mine, which had just reopened in the early 1960s. The mine was located seven miles up Henson Creek and operated for several years before closing. (MM.)

HONKY-TONK MUSIC. Piano player Chris Waldrum tickles the ivories at the Elkhorn Bar in Lake City in the 1950s. Waldrum also played church music, which endeared him to parents. He was famous for being able to play "Wabash Cannonball" with his toes. (LCSW.)

BRICK FACTORY. The Hunt Brothers brick factory, established in the early 1880s, was located at the north end of Lake City near the mouth of Slaughterhouse Gulch. Many of the brick buildings in Lake City were built from bricks produced by the factory. The little girl holding a doll in the doorway is Carolyn Hunt, later Carolyn Wright, who wrote *Tiny Hinsdale of the Silvery San Juan.* (LCSW.)

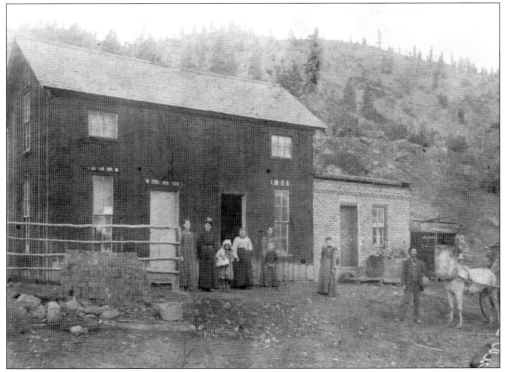

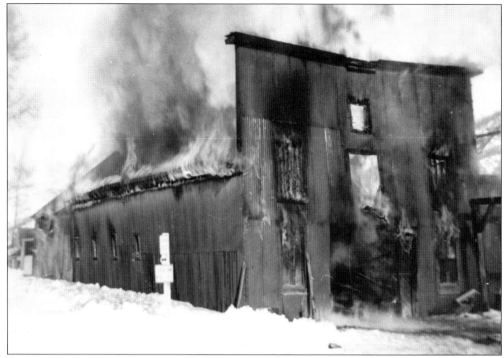

OLD WATSON BARN BURNS. The Old Watson Freight Barn burns in Lake City in 1951. Samuel Watson built the barn in the 1880s, and his freight service carried mining machinery and supplies to nearby mines and ore out to the railroad. At the time of the fire, the barn was used by the Hinsdale County Road Department. The fire destroyed an estimated $60,000 in equipment. (ER.)

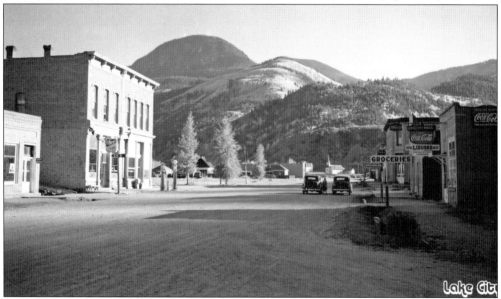

LAKE CITY, 1940s. Lake City is quiet and peaceful on a summer day looking south in 1942. Mike and Stella Pavich owned the brick building on the left—it was a bar, café, liquor store, hotel, and movie theater rolled up into one and is currently the Lake City Arts Center. On the right is a drugstore and the Hoffman grocery store. (LCSW.)

Ten

MODERN MECCA

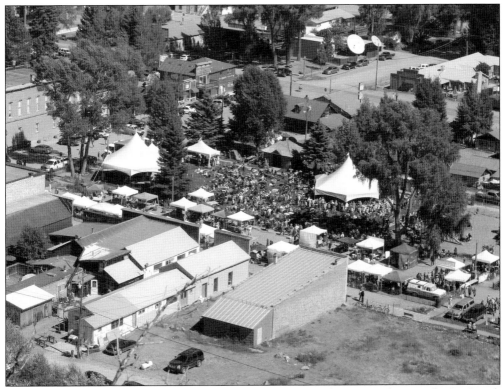

UNCORKED WINE AND MUSIC FESTIVAL. 600 wine and music enthusiasts gather in Lake City's park in September every year to sample a wide selection of wines from all over the nation and also to hear top-ranked bands. It is one of the largest yearly celebrations in Lake City. (RG.)

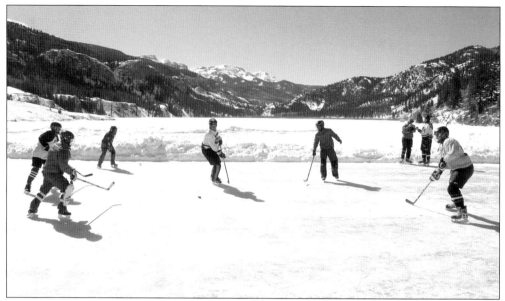

POND HOCKEY. With the Continental Divide in the background, the first annual pond hockey tournament is played on beautiful Lake San Cristobal at over 9,000 feet, just south of Lake City in 2018. (LCSW.)

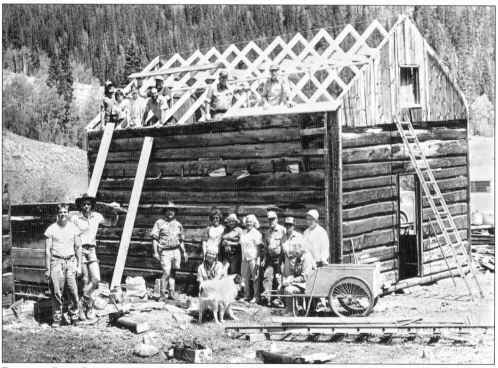

BURROWS PARK RESTORATION, 1989. Located just below 12,600-foot-high Cinnamon Pass, Burrows Park was the site of the promising silver camps of Argentum, White Cross, and Tellurium, each of which had its own post office. Here, Hinsdale County volunteers are stabilizing two 1870s cabins. (LCSW.)

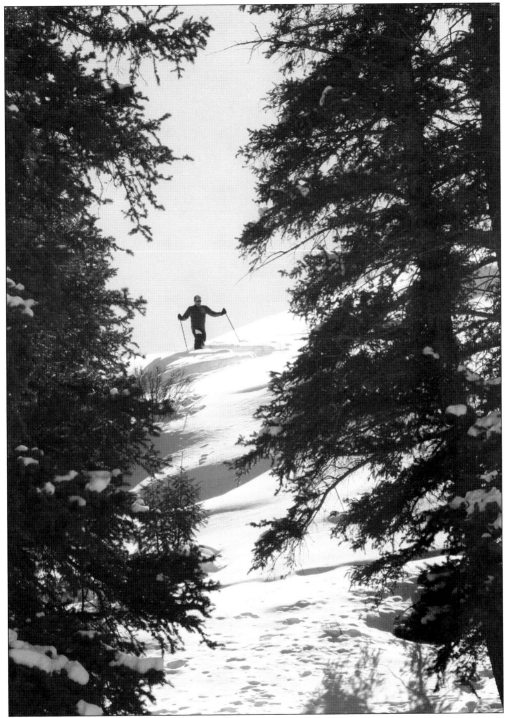

CANNIBAL SNOWSHOE RACE. Named for the famed cannibal Alferd Packer, Lake City hosts a 5- and 10-kilometer snowshoe race every February near Lake San Cristobal. The race goes through some of the most beautiful scenery in Colorado. Here, a racer follows the trail with deep snow on either side of him. (LCSW.)

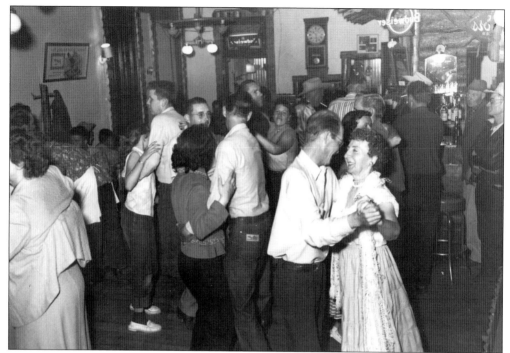

ELKHORN BAR, 1948. The Elkhorn Bar was a thriving restaurant, dance hall, and gambling establishment following World War II. Featuring slot machines and a roulette table, the Elkhorn offered nonstop entertainment from evening through early morning. (MD.)

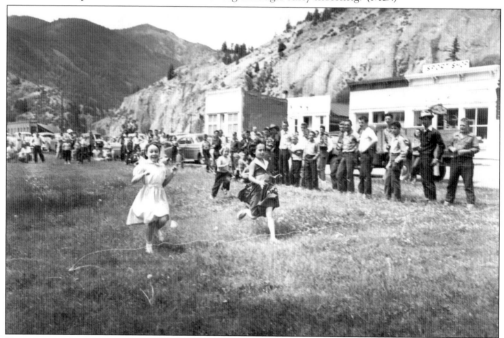

RACE IN THE PARK. Young girls excitedly run a 50-meter race in the park in Lake City on the Fourth of July in 1954. Other games played in the park included nickel and quarter scrambles, sack race, egg toss, and wheel-barrow races. (MD.)

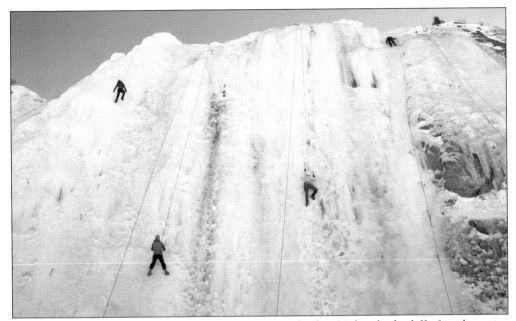

ICE CLIMBING. Located at the mouth of Henson Creek, this 90-foot high cliff of ice hosts ice climbers every February at the Lake City Ice Climbing Festival. Climbers from all over Colorado and the nation compete at one of the top ice walls in the United States. (LCSW.)

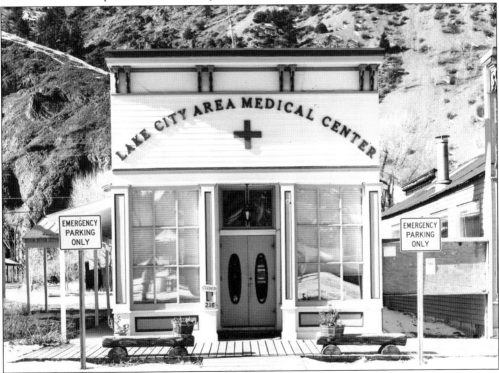

SALOON TO MEDICAL CENTER. Built in 1876 as a saloon, the Lake City Medical Center was in this building from 1975 to 1992. The building is one of Lake City's oldest and is currently occupied by the Silver Street Fine Art Gallery. (BS.)

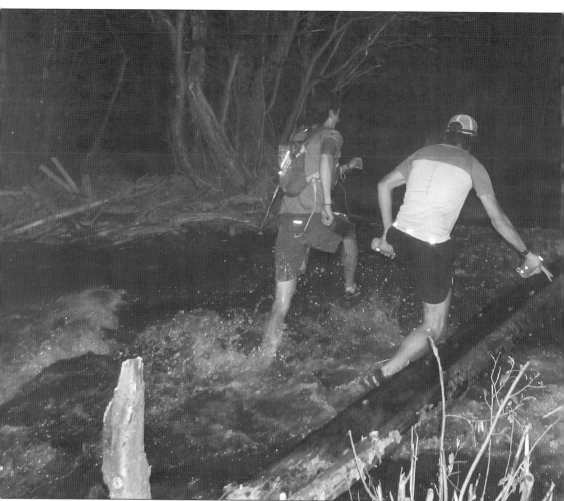

SAN JUAN SOLSTICE. One of the top ultra runs in the nation, the San Juan Solstice is a 50-mile foot race at high elevation. The race involves hundreds of racers chosen from a lottery and begins at 5:00 a.m. in Lake City. Much of the race is run on trails, ranging in elevation from 8,600 to 13,500 feet. The race involves fording rushing streams, climbing mountains, and crossing snowfields and high passes. (RG.)

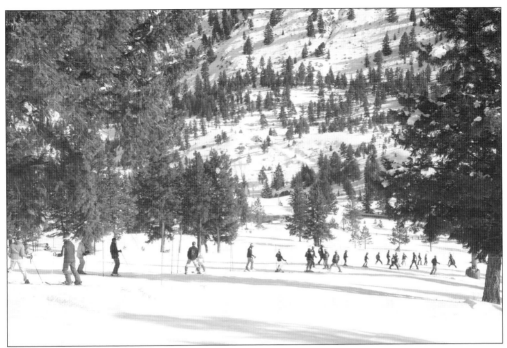

WINTER WONDERLAND.
Started in 1966 on Bureau of Land Management land, the Lake City Ski Area still operates today, complete with a poma lift and a 300-foot vertical drop. Here, Henry Woods, Hinsdale County ski coach, leads a group of young racers in 2017 surveying the slalom course. (LCSW.)

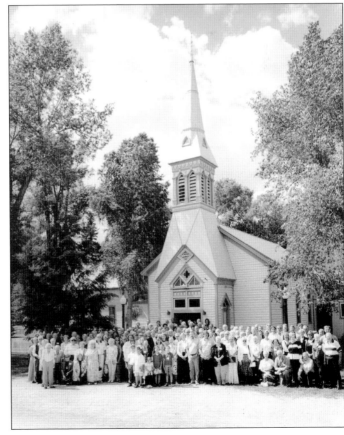

WESTERN SLOPE'S OLDEST.
The famed Lake City Presbyterian Church was built by missionaries George and Alexander Darley in 1876 and is the oldest church on the Western Slope of Colorado. Services are still held every Sunday to a packed congregation. Here, the congregation gathers outside the church in 2001 to commemorate its 125th anniversary. (BS.)

HINSDALE COUNTY COURTHOUSE.
Built in 1877 and the oldest
operating courthouse in Colorado,
this famous building was used for
the Alferd Packer trial in 1883. The
courthouse also hosted Susan B.
Anthony, the famed champion of
woman's rights, in 1877. (LCSW.)

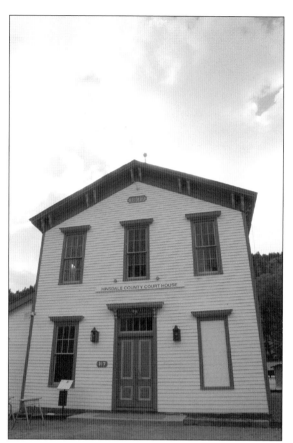

MOON OVER LAKE CITY. Taken by
famed photographer Bob Stigall in
December 1991, this picture shows
the stark and incredible beauty of
the once-great metropolis of the San
Juan Mountains in Lake City. (BS.)

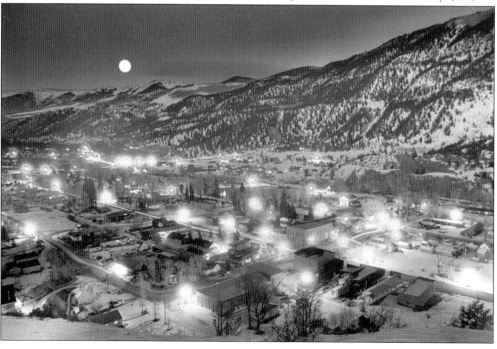

BIBLIOGRAPHY

Colwell, Raymond G. *Lake City.* Denver, CO: University of Denver Press, 1950.

Darley, George. *Pioneering in the San Juan.* Chicago, IL: Fleming H. Revell Co., 1899.

Houston, Grant E. *Lake City Reflections.* Lake City, CO: B&B Printers, 1976.

Kaplan, Michael. *Otto Mears: Paradoxal Pathfinder.* Silverton, CO: San Juan Book Co., 1982

Kushner, Ervan. *Alfred Packer, Cannibal! Victim?* Frederick, CO: Platte and Press, 1980.

Lake City Silver World. Various articles, 1876–2018.

Ruffner, Lt. E.H. *Report of a Reconnaissance in the Ute Country Made in the Year 1873.* Washington, DC: US War Department, 1874

Smith, P. David. *The Story of Lake City, Colorado and Its Surrounding Areas.* Lake City, CO: Western Reflections Publishing Co., 2016.

Thompson, Thomas Gray. "The Social and Cultural History of Lake City, Colorado, 1876 to 1900." Master's thesis, University of Oklahoma, 1974.

Vandenbusche, Duane and Walter Borneman. "Lake City Branch." *Colorado Rail Annual* No. 14 (1979): 25–109.

Wallace, Betty. *Epitaph for an Editor: A Century of Journalism in Hinsdale and Gunnison Counties, 1875–1975.* Gunnison, CO: B&B Printers, 1987.

Wright, Carolyn and Clarence. *Tiny Hinsdale of the Silvery San Juans.* Lake City, CO: privately printed, 1964.

DISCOVER THOUSANDS OF LOCAL HISTORY BOOKS FEATURING MILLIONS OF VINTAGE IMAGES

Arcadia Publishing, the leading local history publisher in the United States, is committed to making history accessible and meaningful through publishing books that celebrate and preserve the heritage of America's people and places.

Find more books like this at
www.arcadiapublishing.com

Search for your hometown history, your old stomping grounds, and even your favorite sports team.